19th Century Engravings Of Italy

Engravings from J. Gourdault's L'Italie 1877

Colored by

Dwight Cook

Copyright © 2016 by Dwight Cook

All rights reserved.

Front Cover: The Shores of Naples and Salerno (page 67)

Introduction

Jules Gourdault was a Frenchman who in the late 1800s published a number of books dealing with his travels to various European countries. He was the Fodor or Frommer of travel authors for his time. No, maybe more like Rick Steves of PBS TV fame, for his books had more to do with history than where to eat or stay.

Being of Italian descent and curious about Italian history I first came across Gourdault's books about his travels in Italy. There were various editions but the largest one was published in 1877 and had the most illustrations. This book in good condition can cost more than $300 whenever a copy comes up for auction. The illustrations or engravings were for the most part extremely detailed, done by various artists of the time and depicted scenes from different towns, villages and regions of Italy and Sicily. The narrative accompanying these engravings were, of course, in French and dealt with the history, geography and customs of these places. But it was the engravings that caught my eye.

I thought it was unfortunate the public was in general unaware of these fantastic engravings. The 1877 hardcover edition is somewhat obscure and expensive. And being in French most people would not know the locations that are depicted in these engravings. Also, given the relatively small size of the engravings I felt color would bring many of these to life. So this book presents some of what I consider the best engravings of Gourdault's 1877 book in color with brief descriptions in English at an affordable price. A map of Italy shows the locations in Italy of the scenes depicted in the engravings (numbers shown on the map are location numbers from the table of contents, not page numbers).

Dwight and his wife, Pamela, have published ten books dealing with the genealogies of various families. Shown on the next page is a photo taken by Pam when they were in Monte Sant Angelo, Italy researching Dwight's Italian ancestors. The engraving below shows Monte Sant Angelo in the 1800s. As you can see from the photo, the town hasn't changed that much in almost 150 years.

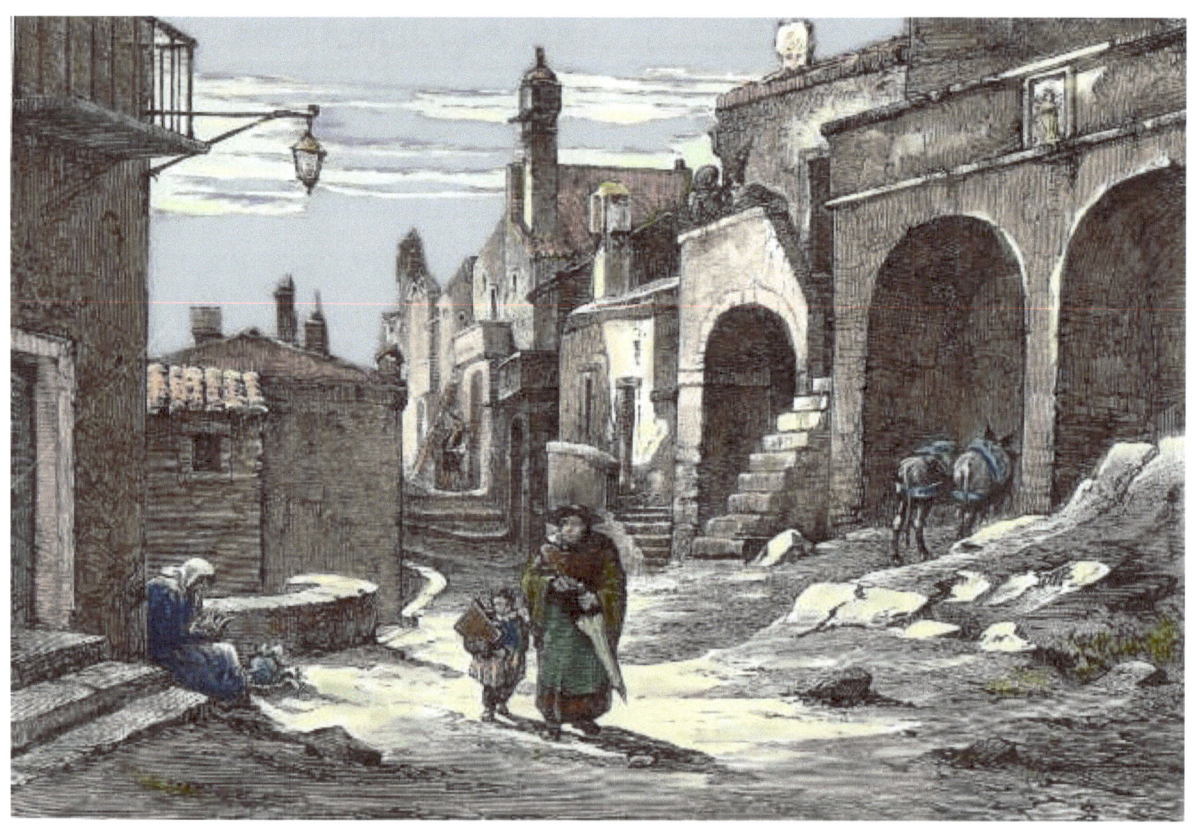

Monte Sant Angelo in the 1800s

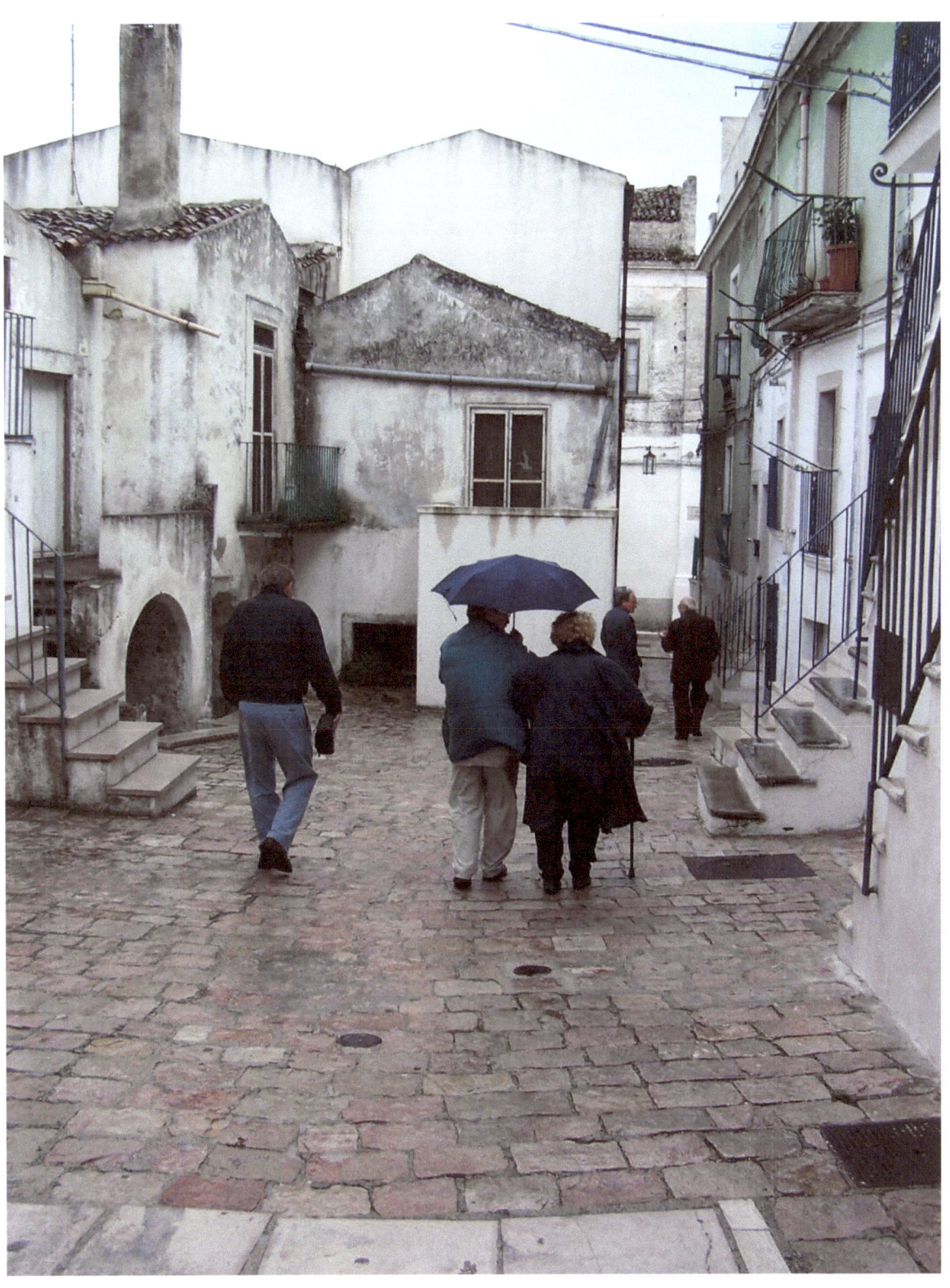

Present Day Monte Sant Angelo

Table of Contents

		Page
1.	Capri	9
2.	Trentino	11
3.	Naples	13
4.	Tivoli	15
5.	Island of Torcello	17
6.	Roman Campagna	19
7.	Porto Venere	21
8.	Terracina	23
9.	Bellaggio	25
10.	La Trantella	27
11.	Acqua Acetosa	29
12.	Gulf of Naples	31
13.	Simplon Pass	33
14.	Posillipo	35
15.	Arpino	37
16.	Columbus, Sicily	39
17.	St. Peters, Rome	41
18.	Cumes, Posillipo	43
19.	Bracciano	45
20.	Appian Way	47
21.	Pallanza	49
22.	Monte Sant Angelo	51
23.	Brenner Pass	53
24.	Arco	55
25.	Tivoli	57
26.	Terni	59
27.	Ariano Irpino	61

28.	Trentino	63
29.	Sorrento	65
30.	Naples/Salerno	67
31.	Bath of Diana/Naples	69
32.	St. Elmo, Naples	71
33.	Naples	73
34.	Map of Italy	75

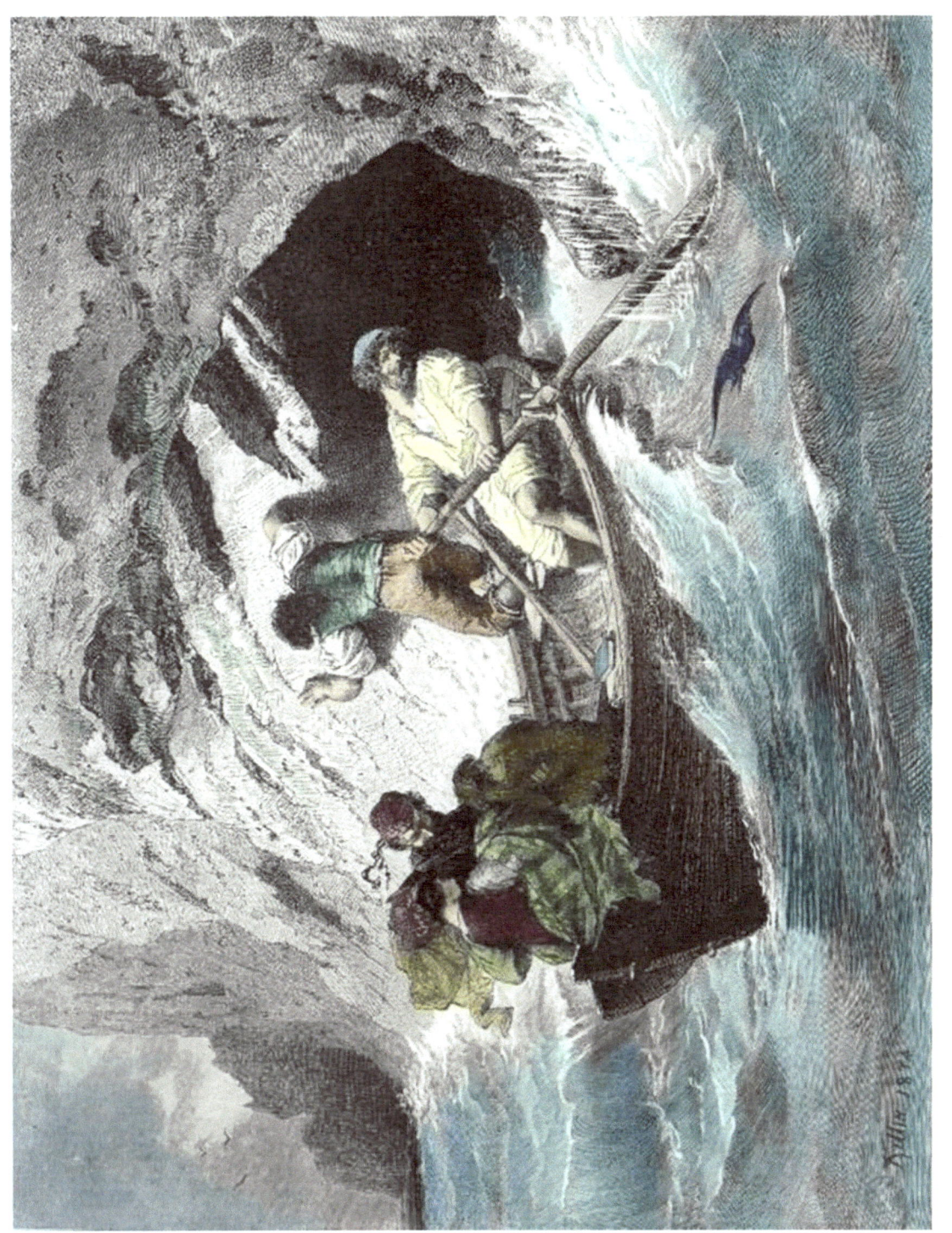

Entrance to the Blue Groto – Sea Cave on the coast of the Island of Capri

Used as a swimming hole for Emperor Tiberius around 30 AD

10

Town in the Northern Province of Trentino

North Shore of Lake Garda

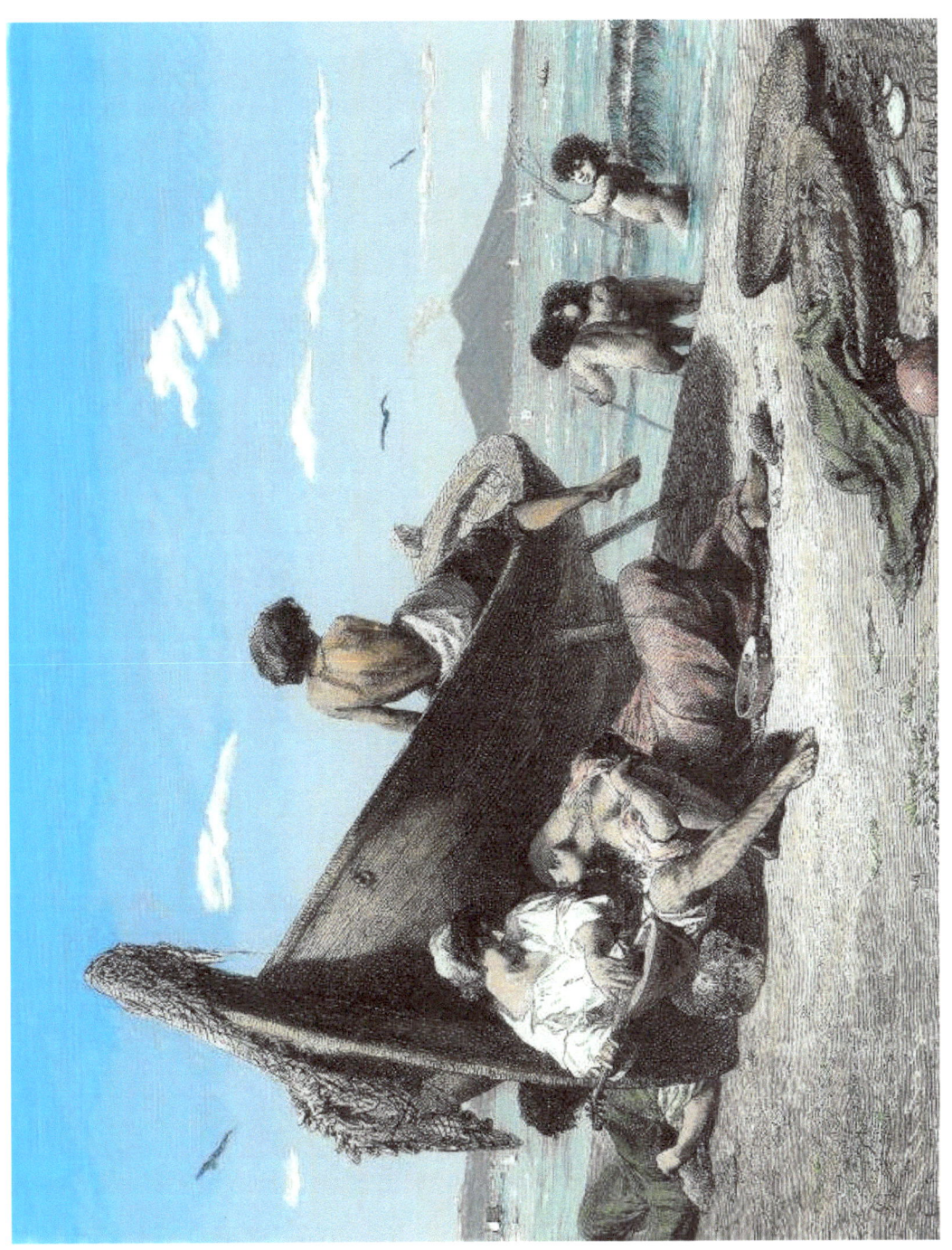

Naples

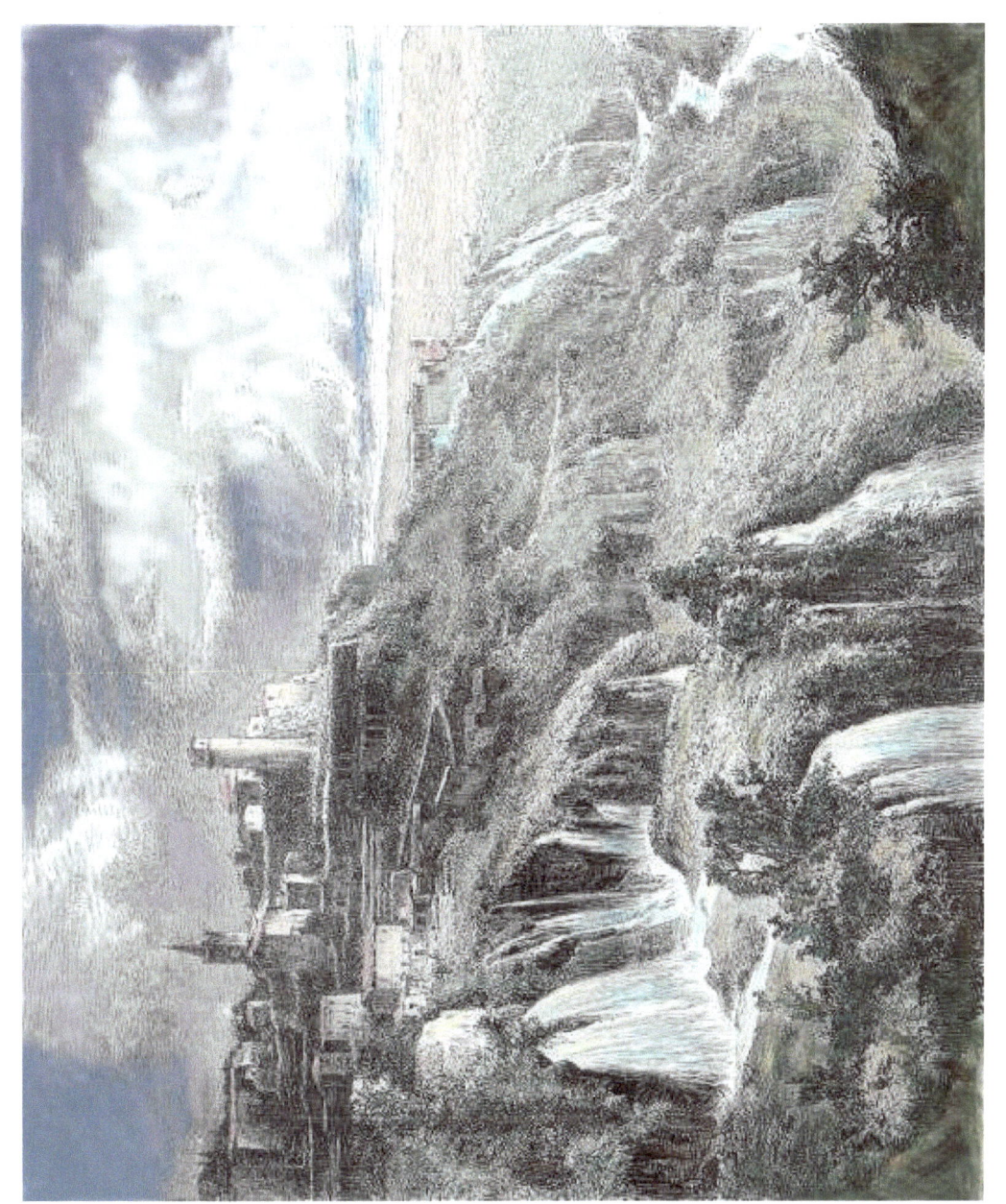

Historic Hilltown, Tivoli, in Lazio Region in Province of Rome

30 km NE of Rome

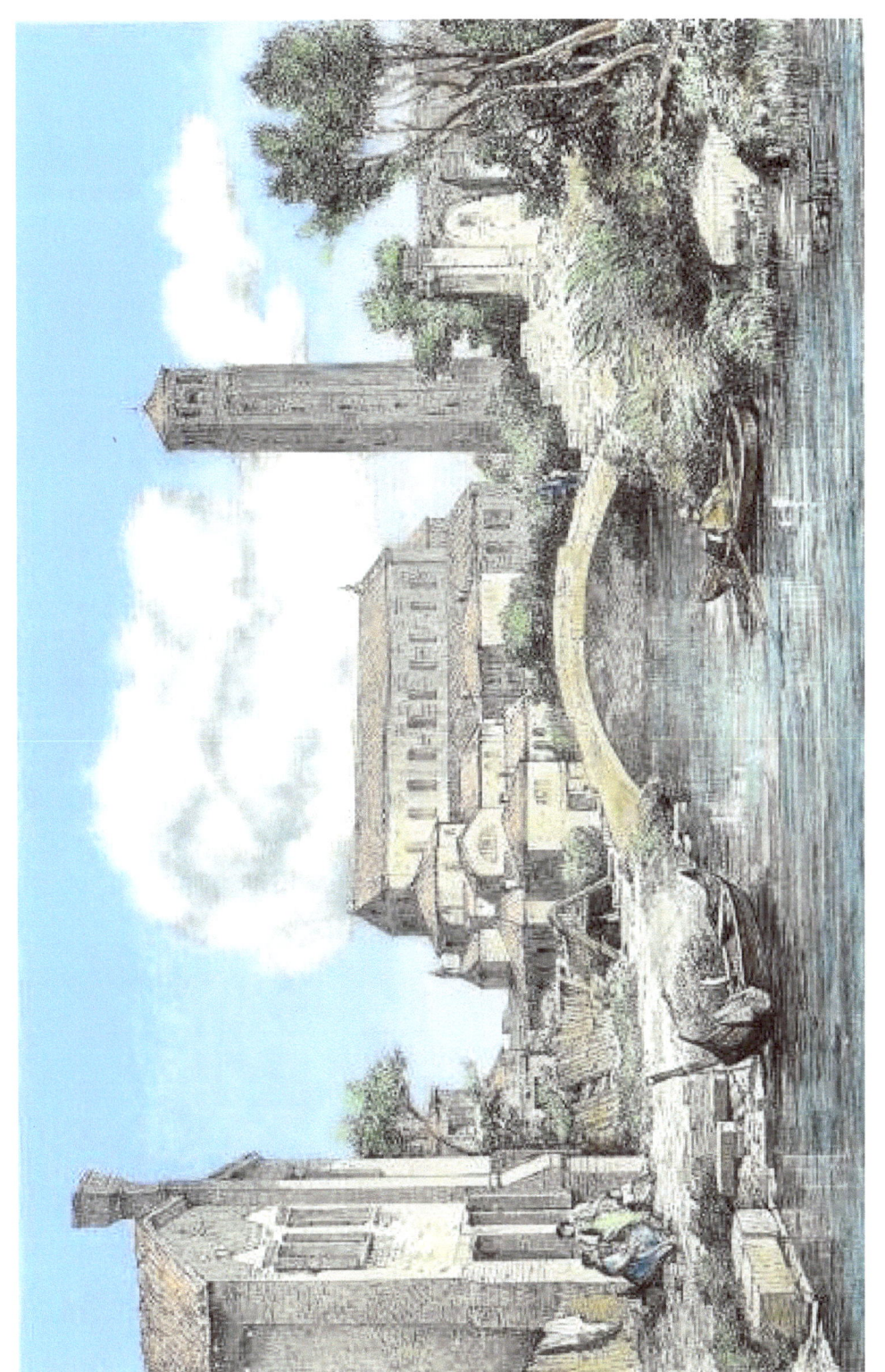

Island of Torcello - Northern End of Venetian Lagoon

Chioggia, Fishing Town

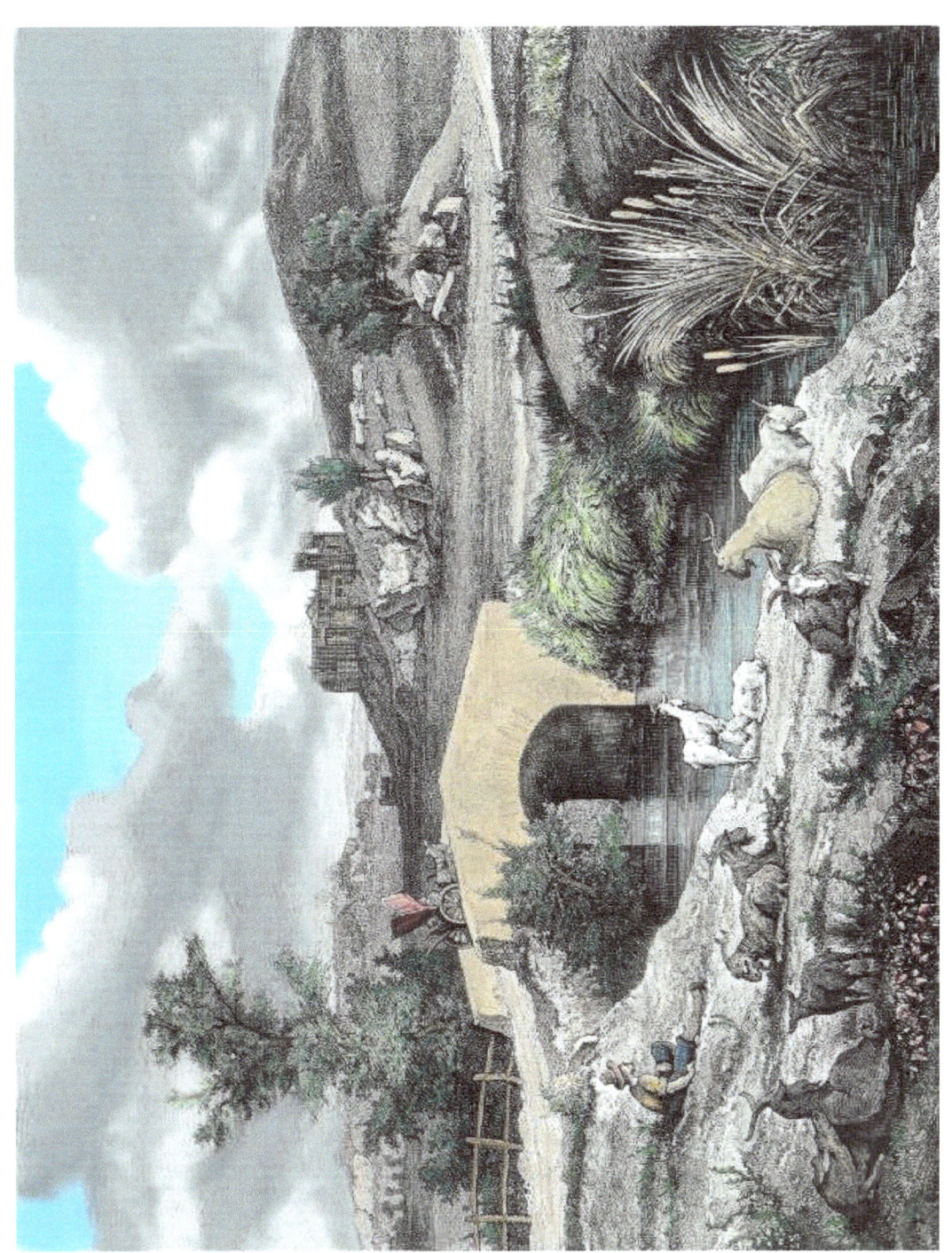

The Promenade of Poussin – Roman Campagna

The Artist Carot painted around 1827 Landscapes outside Rome

Called "La Promenade de Poussin"

Poussin lived in the 1600s

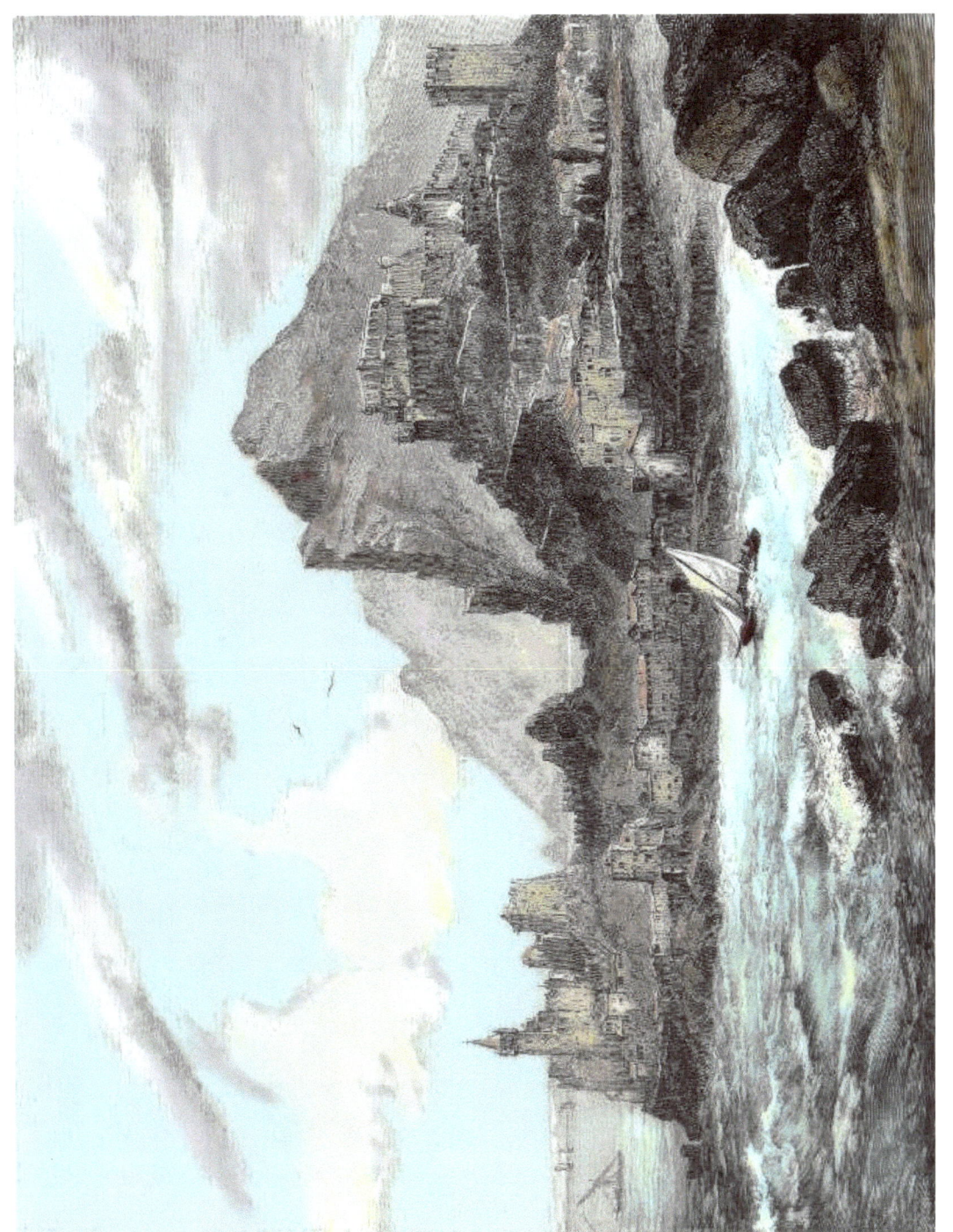

Promontory (Headland) of the Porto Venere on Ligurian Coast in Province of La Spezia

114 km SE of Genoa in Northern Italy

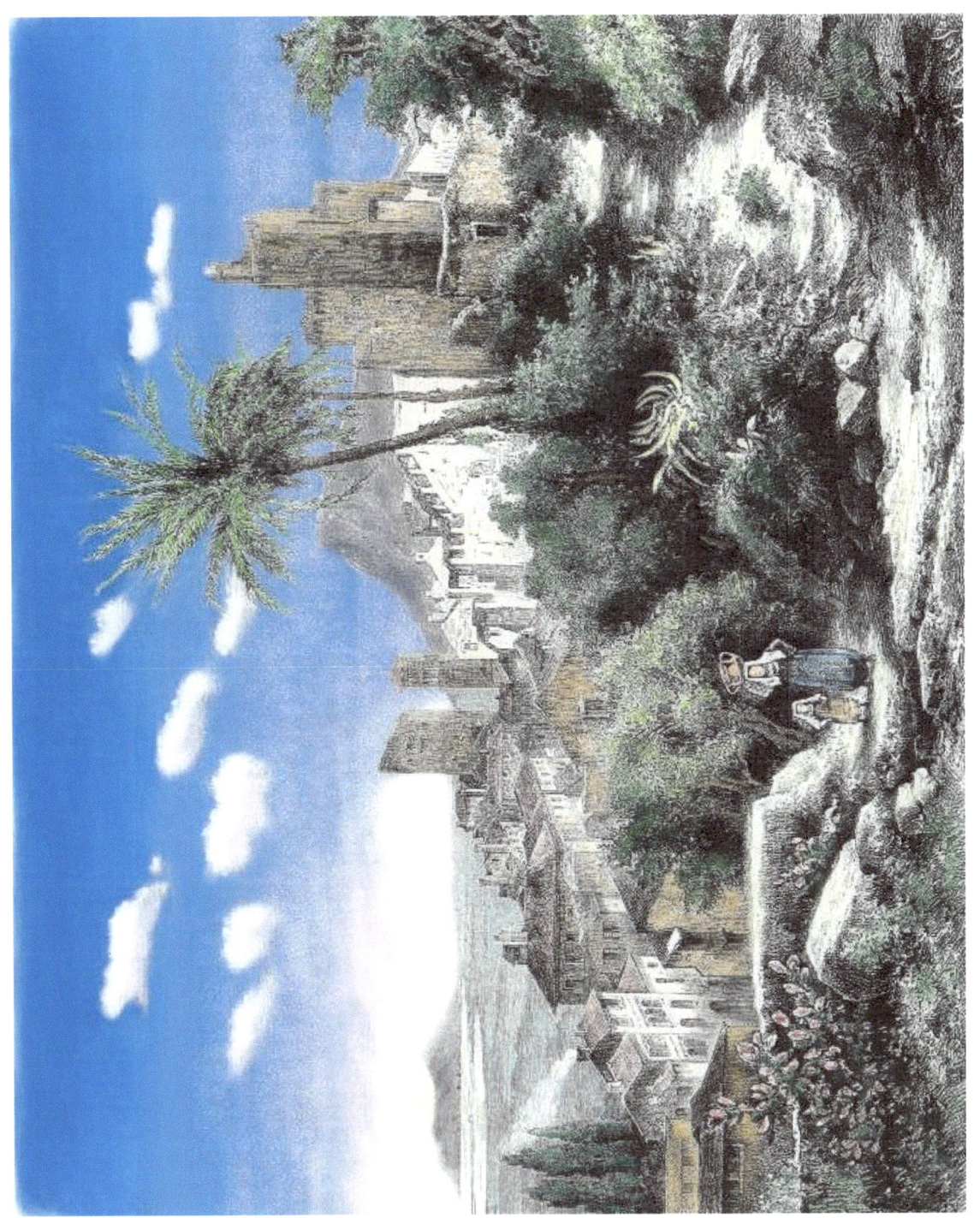

Terracina – Town in Province of Latina in Region of Lazio

76 km SE of Rome – halfway between Rome and Naples

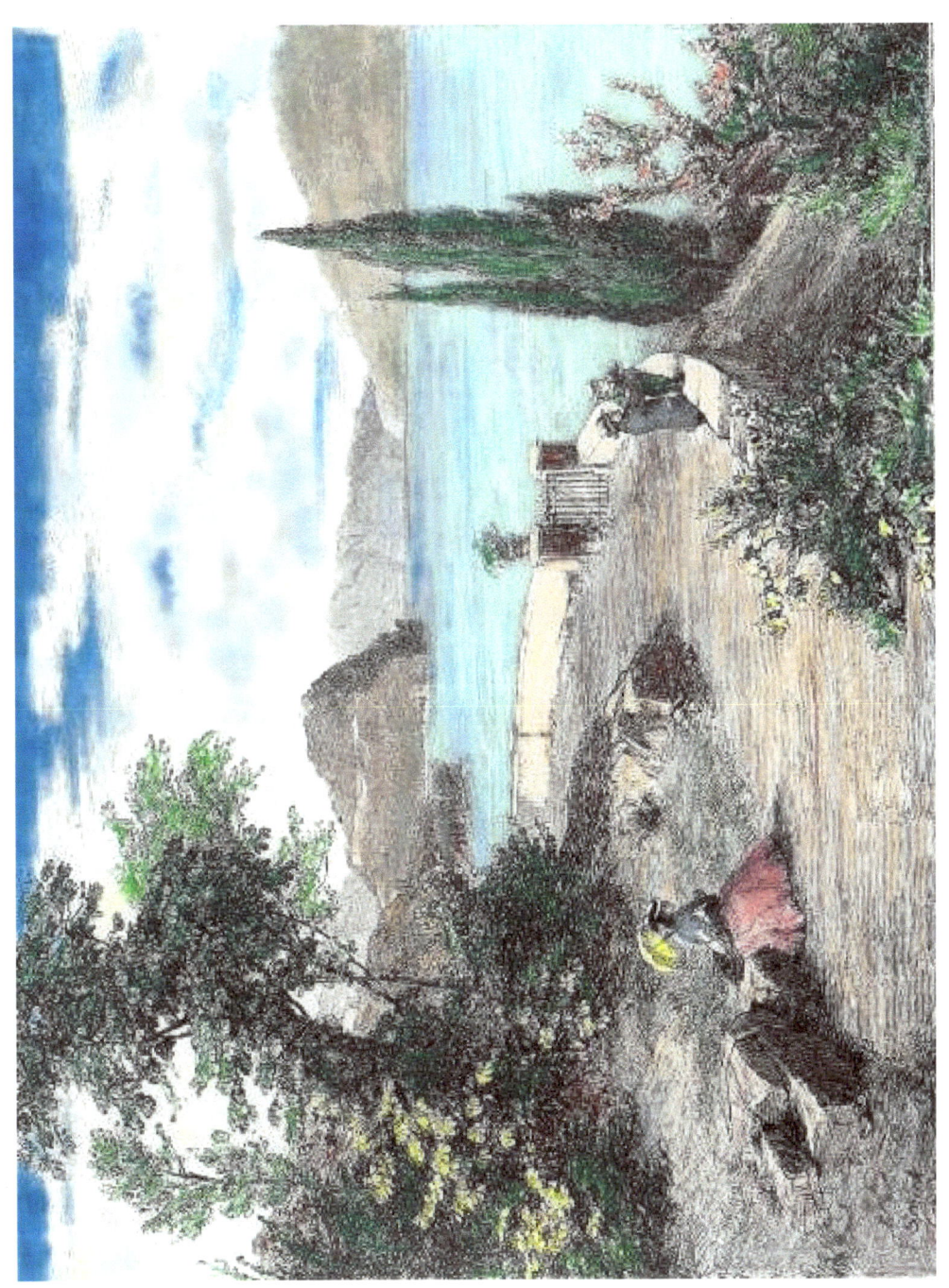

Bellagio is a commune in the Province of Como in the region of Lombardy

Located on Lake Como

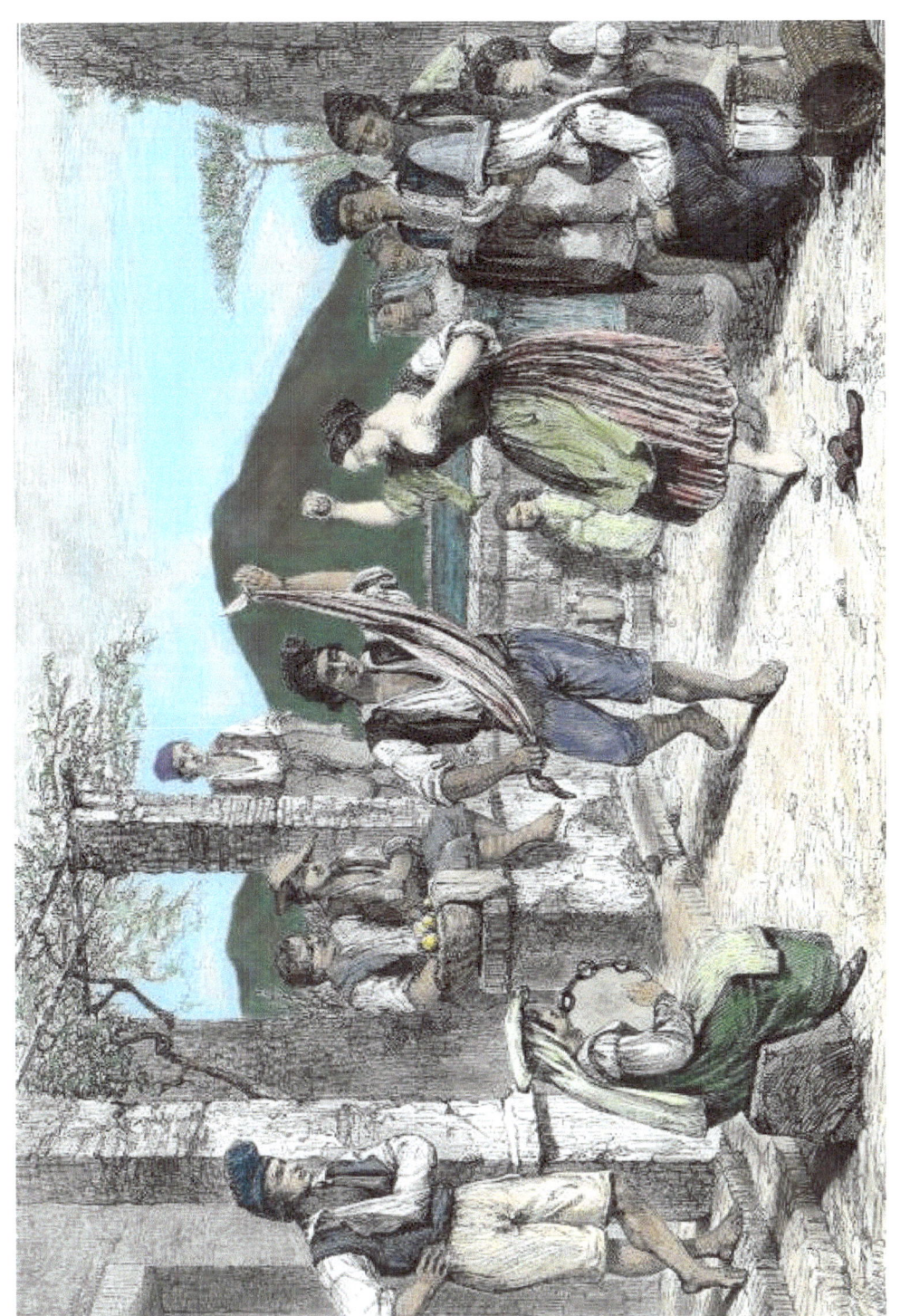

La Tarantella

Popular Native Dance of Southern Italy

(to cure sickness and as a dance of courtship)

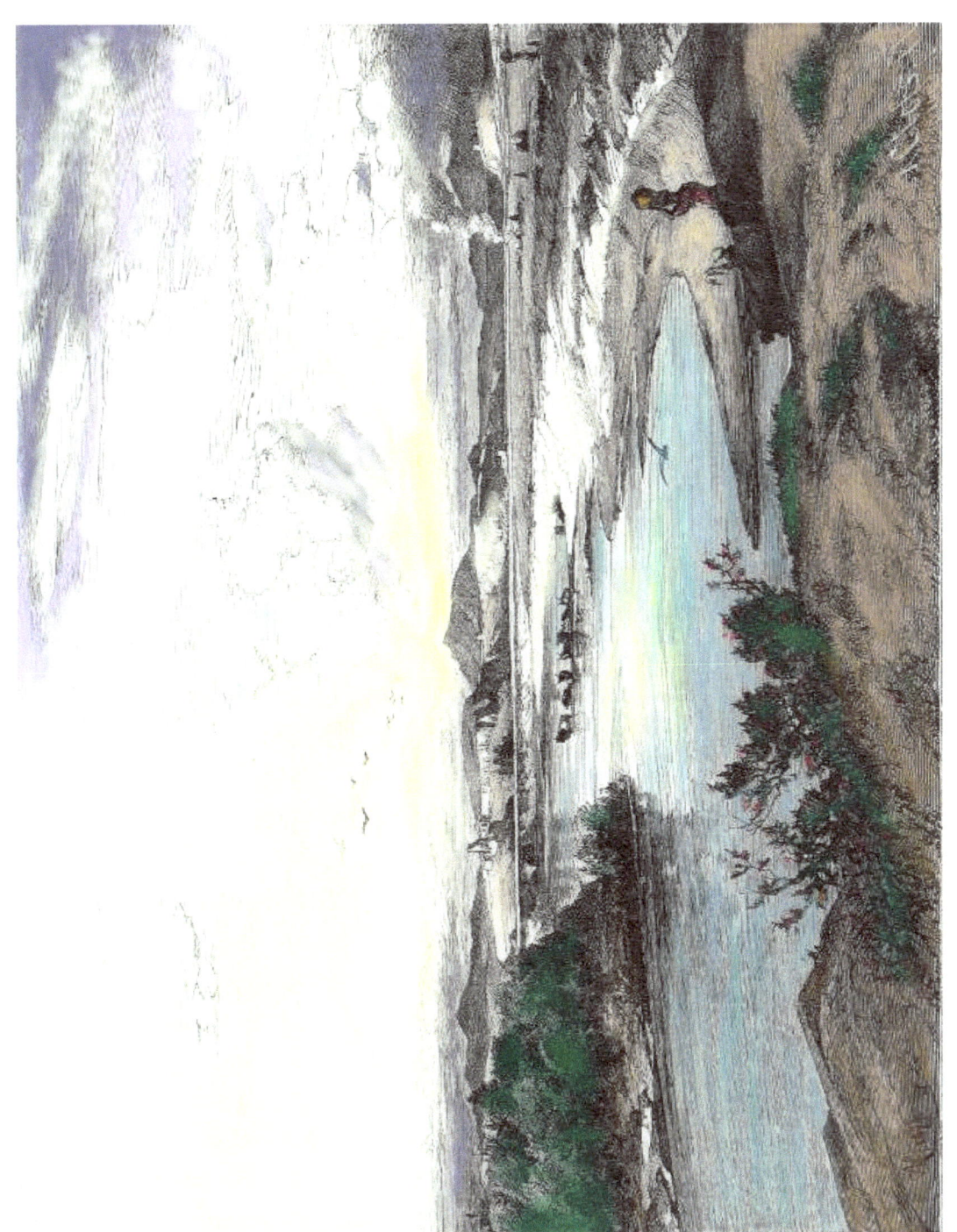

Acqua Acetosa - area north of Rome where Tiber River runs through

Soratte (Soracte) is a mountain ridge in the Province of Rome

30

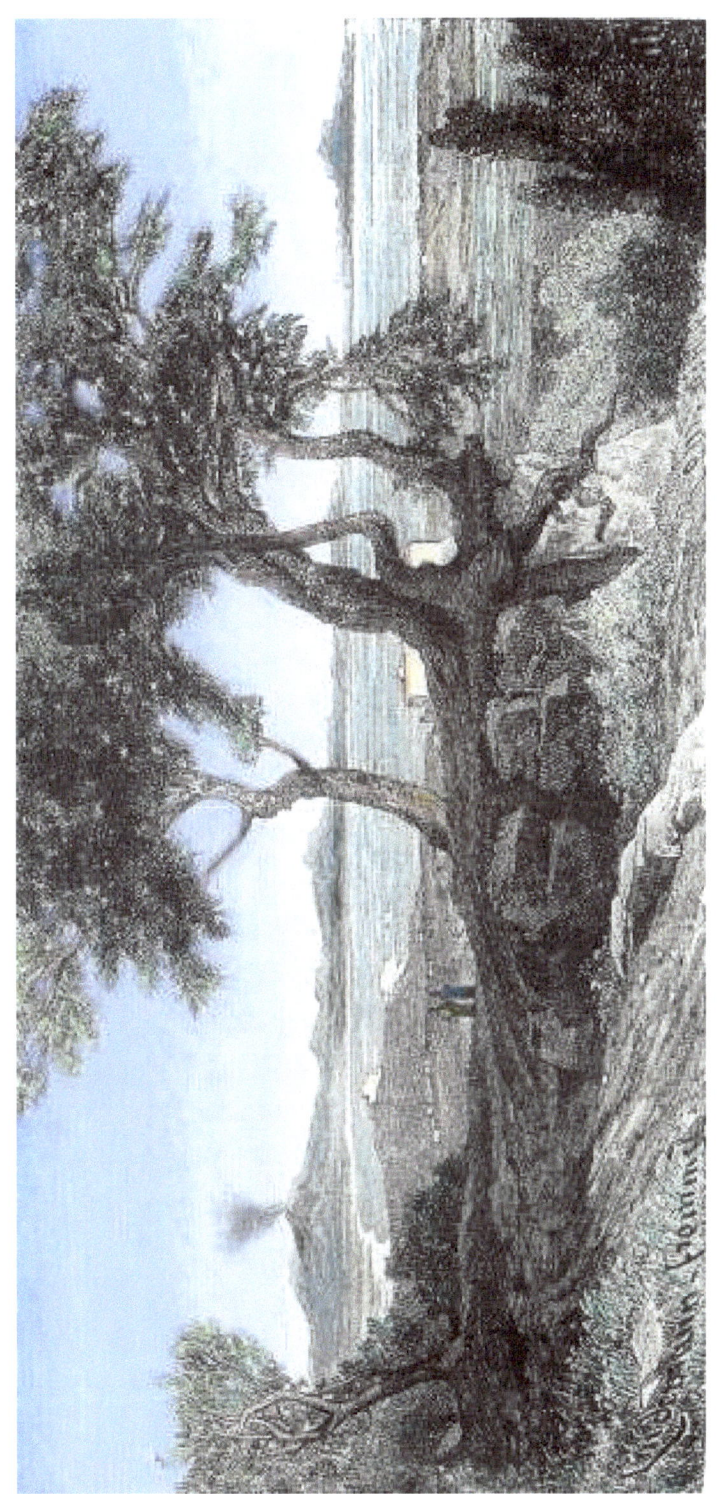

The Islands of Naples and Sorrento

View of Gulf of Naples and Mt. Vesuvius and Camaldoli

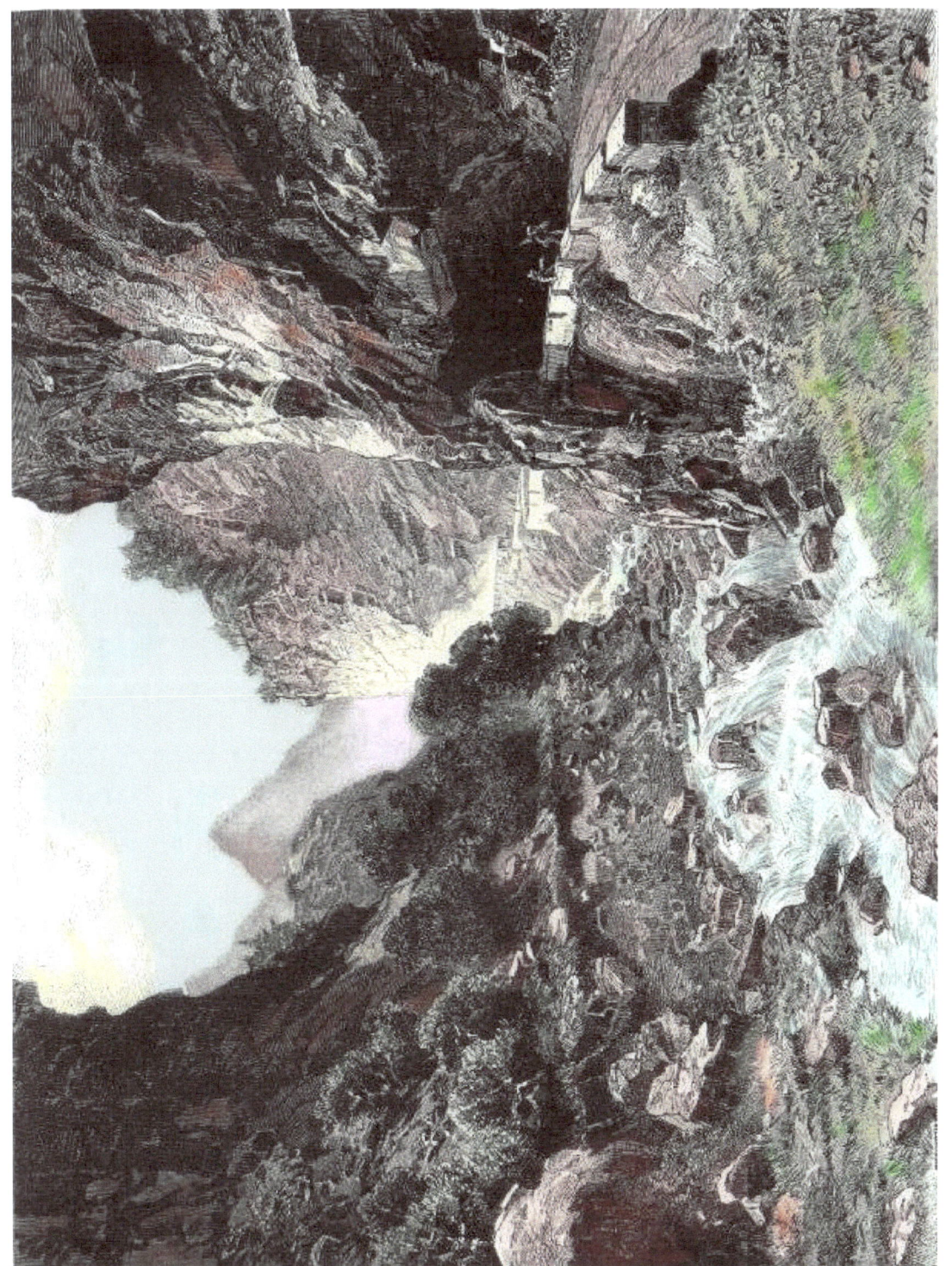

Simplon Pass – high mountain pass between the Pennine Alps and the Lepontine Alps

Constructed in 1801-1805 between Piedmont, Italy and Switzerland

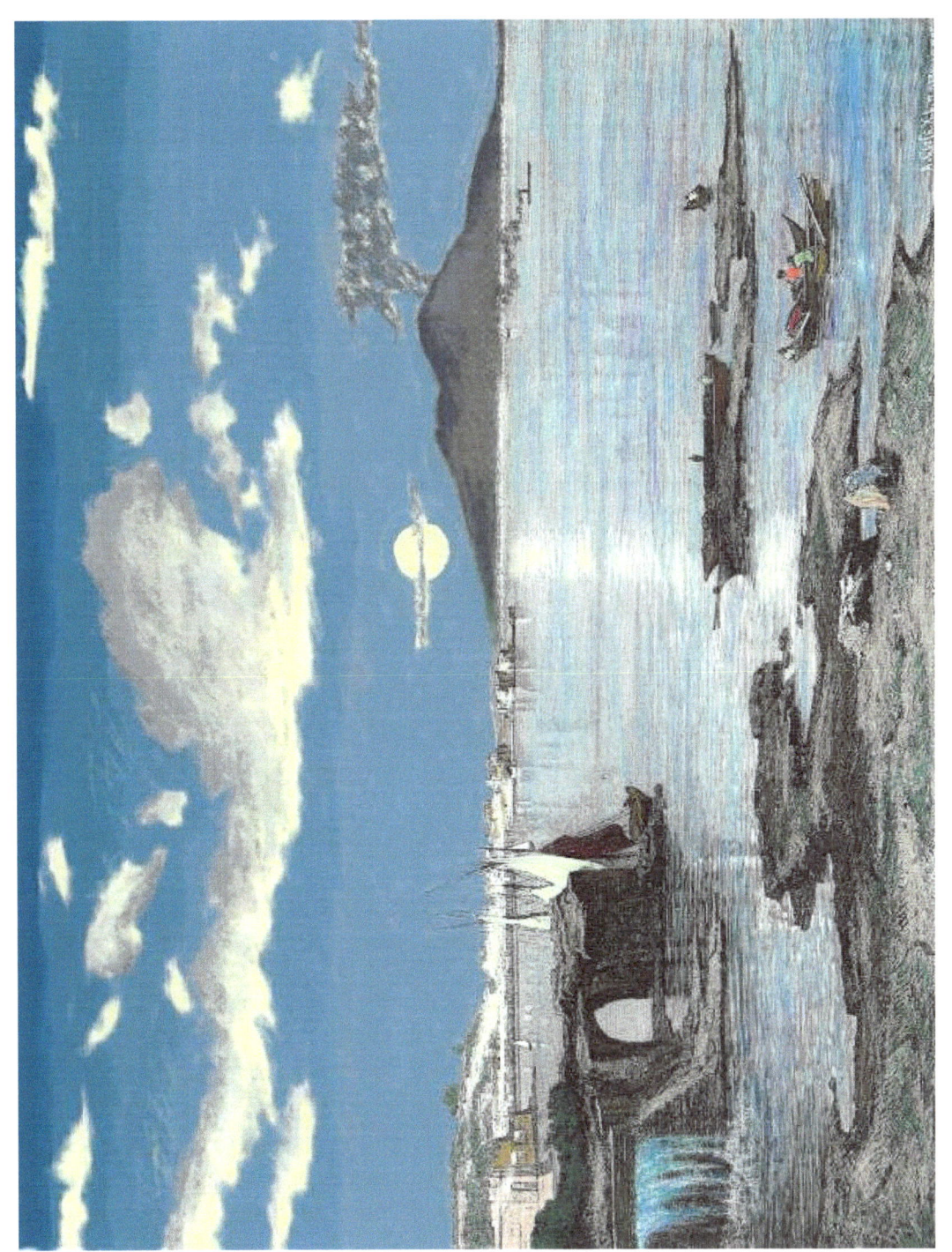

Pausilippe (Posillipo), Resisdential Quarter of Naples

On Northern Coast of the Gulf of Naples

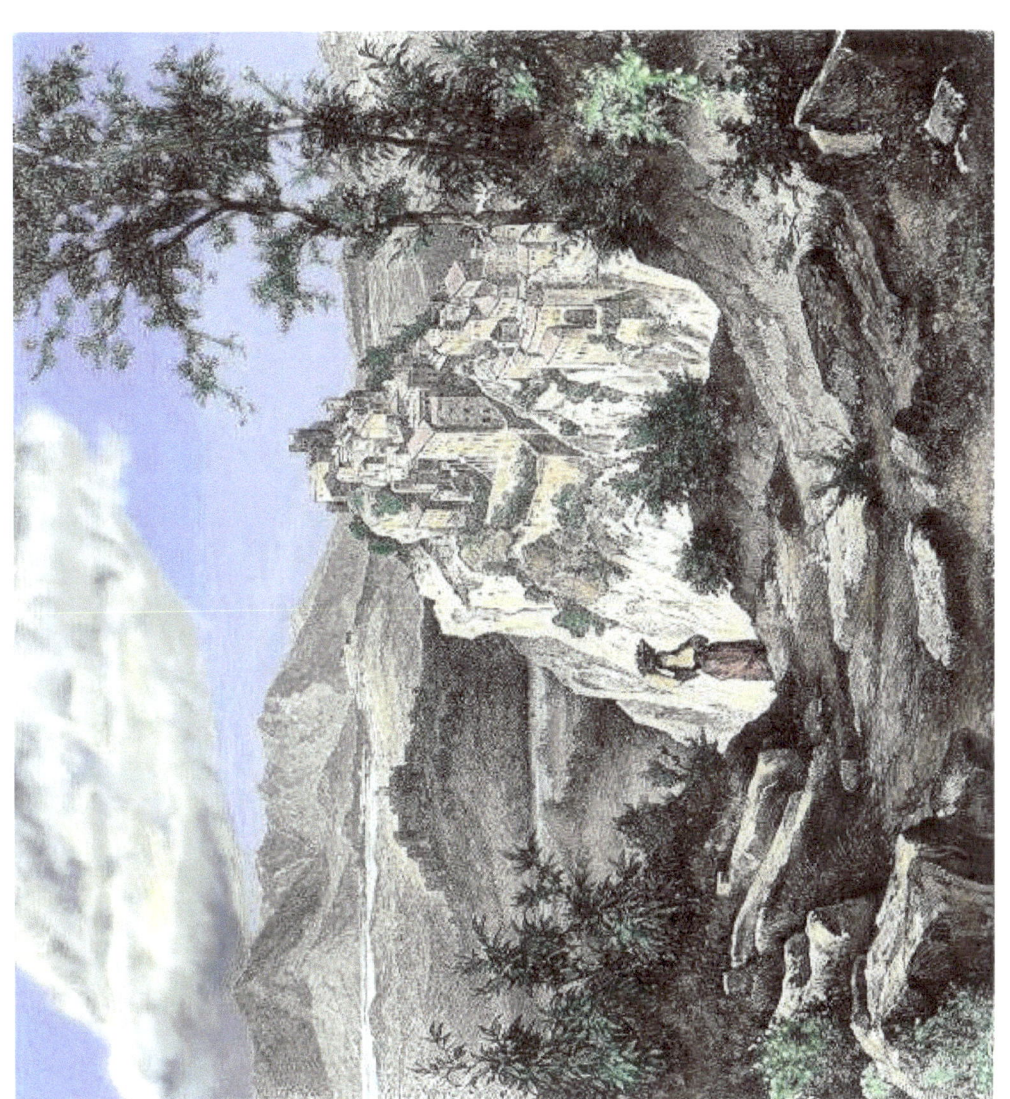

Arpino, on the edge of the Pontine Marshes - a Commune in Province of Frosinone

In Region of Lazio in Central Italy about 60 miles SE of Rome

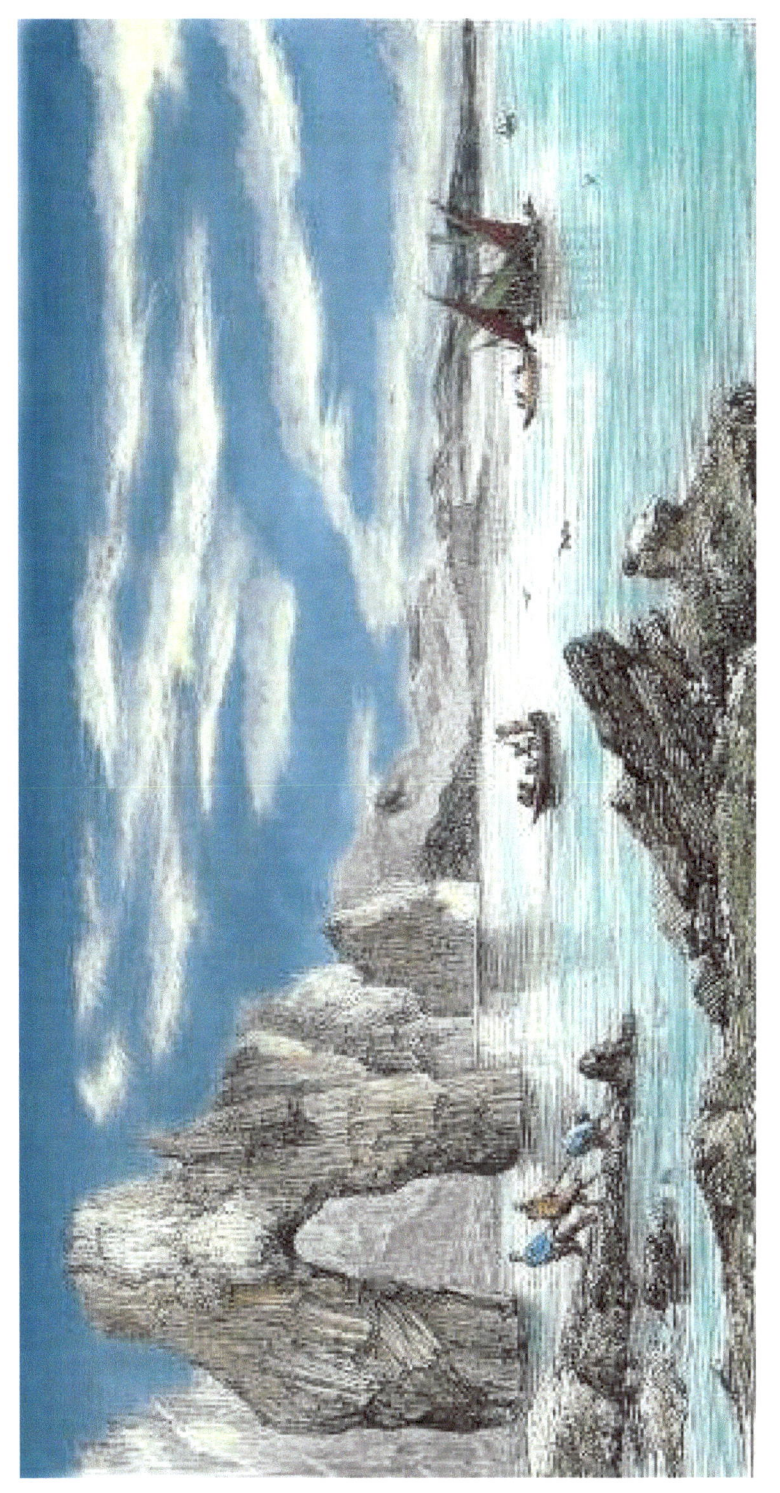

Grotto (Cave) of Columbus, Sicily

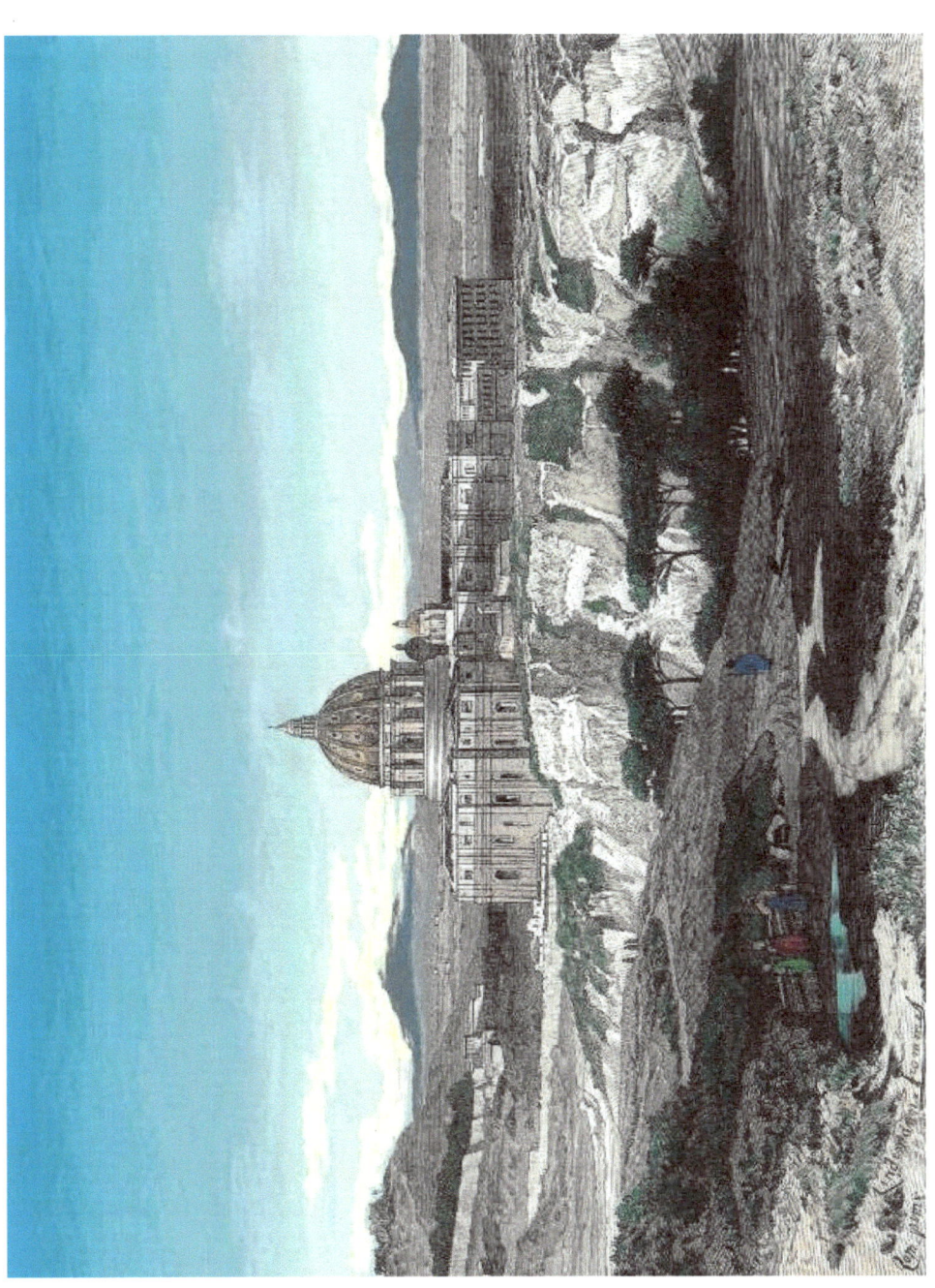
Saint Pietro (Peters) Basilica

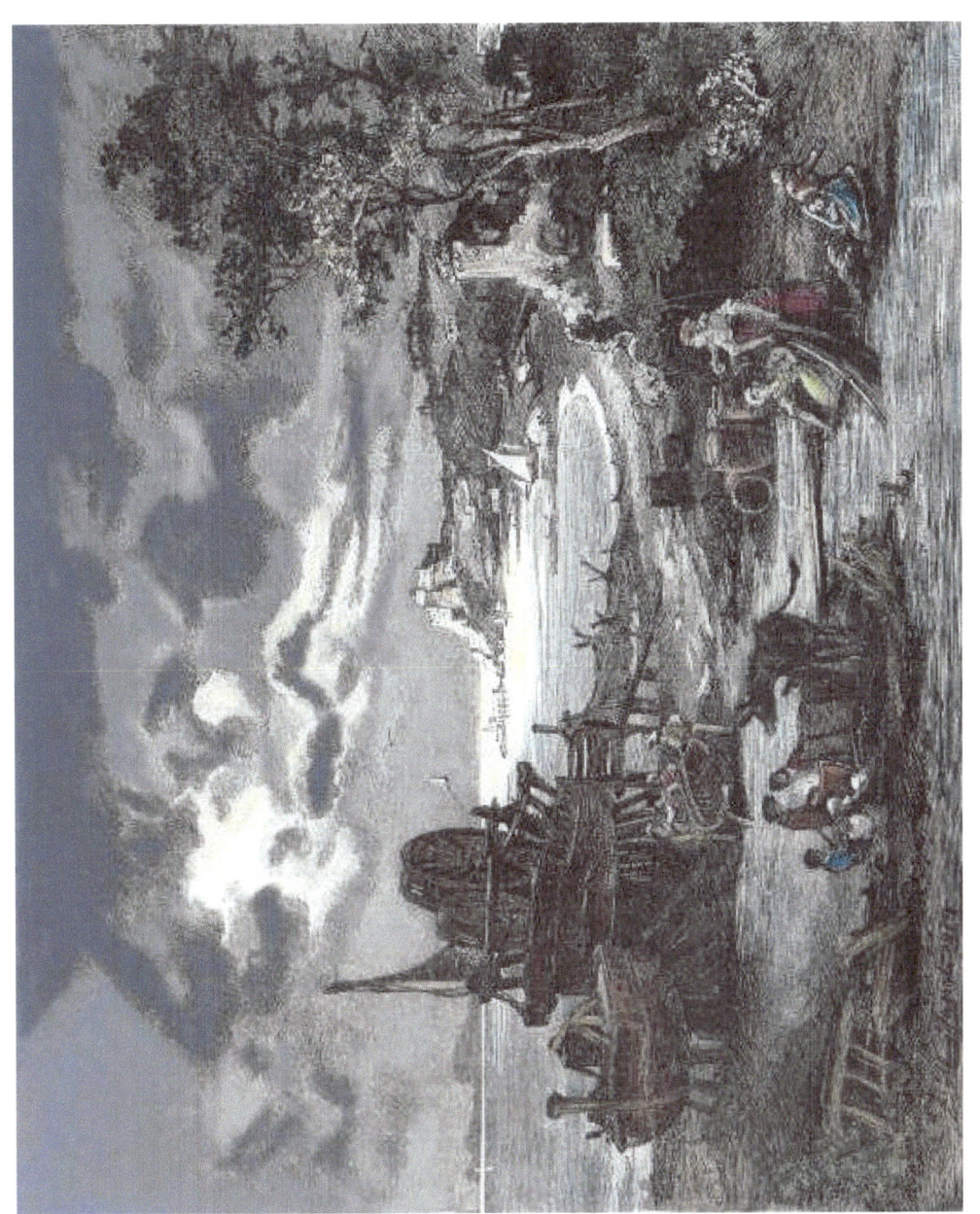

Posillipo on northern coast of Gulf of Naples

In the ruins of Greek colony of Cumes

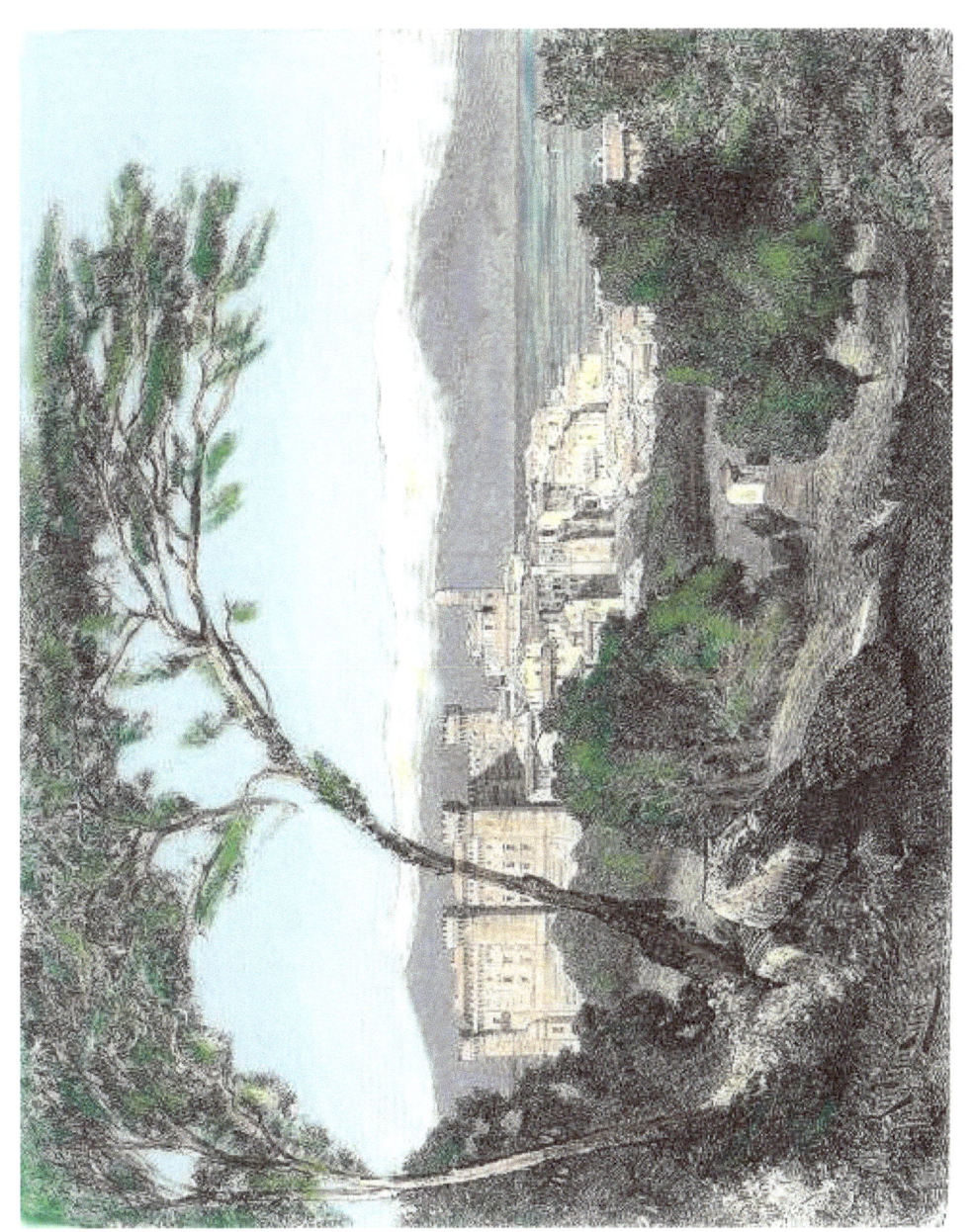

Bracciano, on shores of volcanic lake, town in Lazio region

19 miles NW of Rome

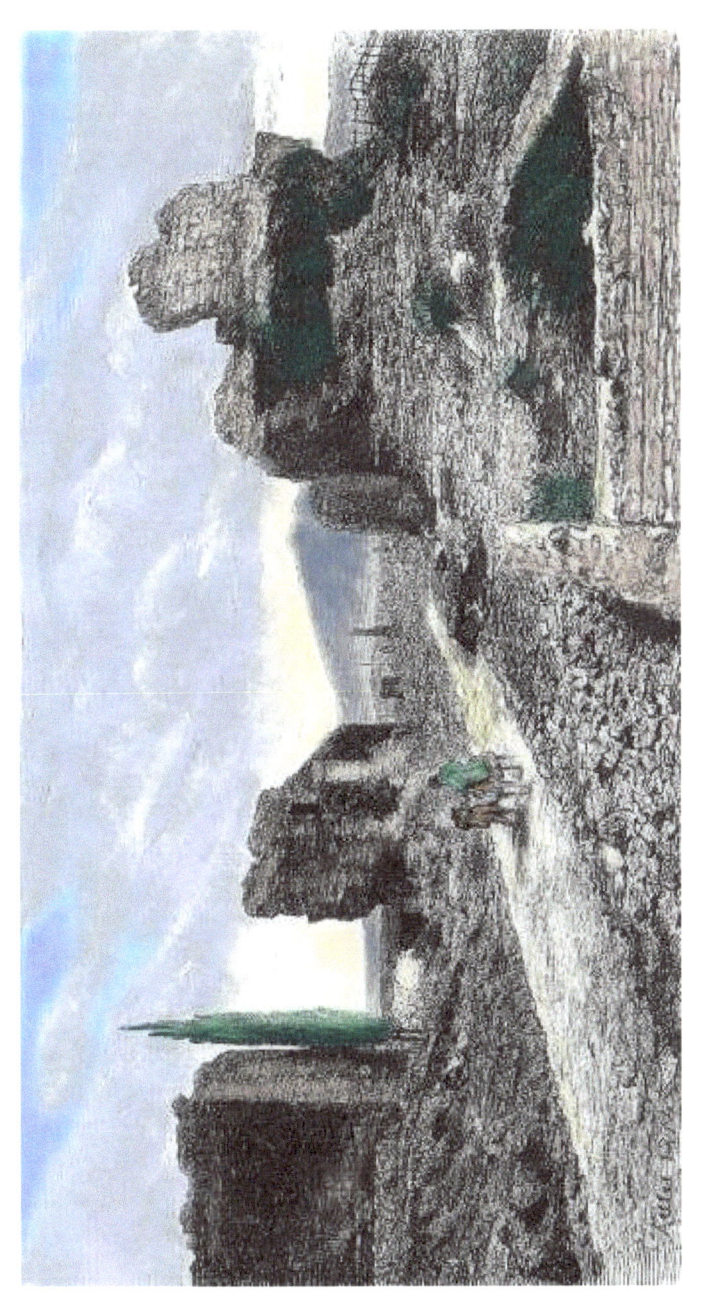

Historic Road, the Appian Way, built in 312 BC
Connecting Rome to Southern Italy

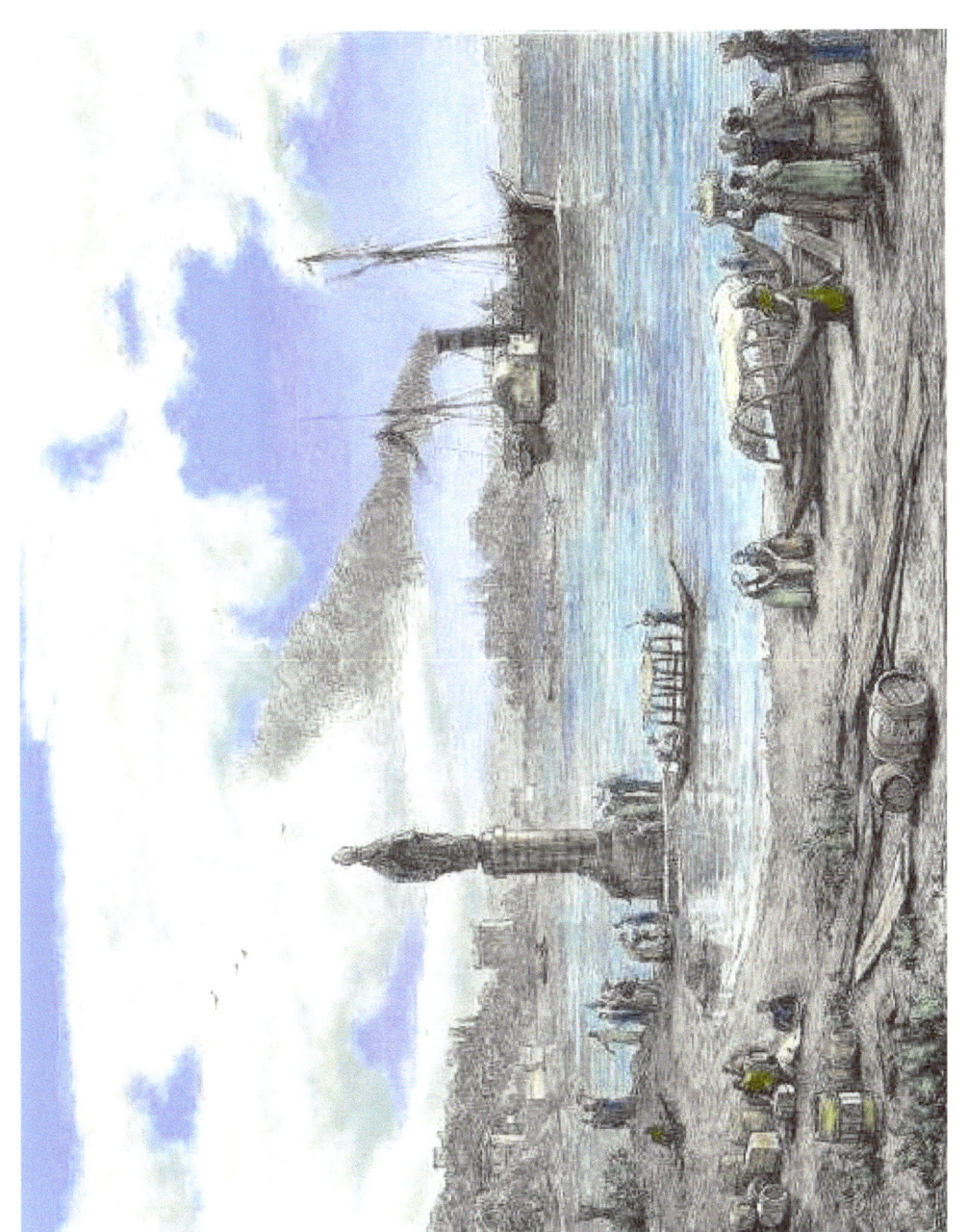

Town of Pallanza on Lake Maggiore, south side of the Alps between Italian regions of Piedmont and Lombardy and the Swiss canton of Ticino

50

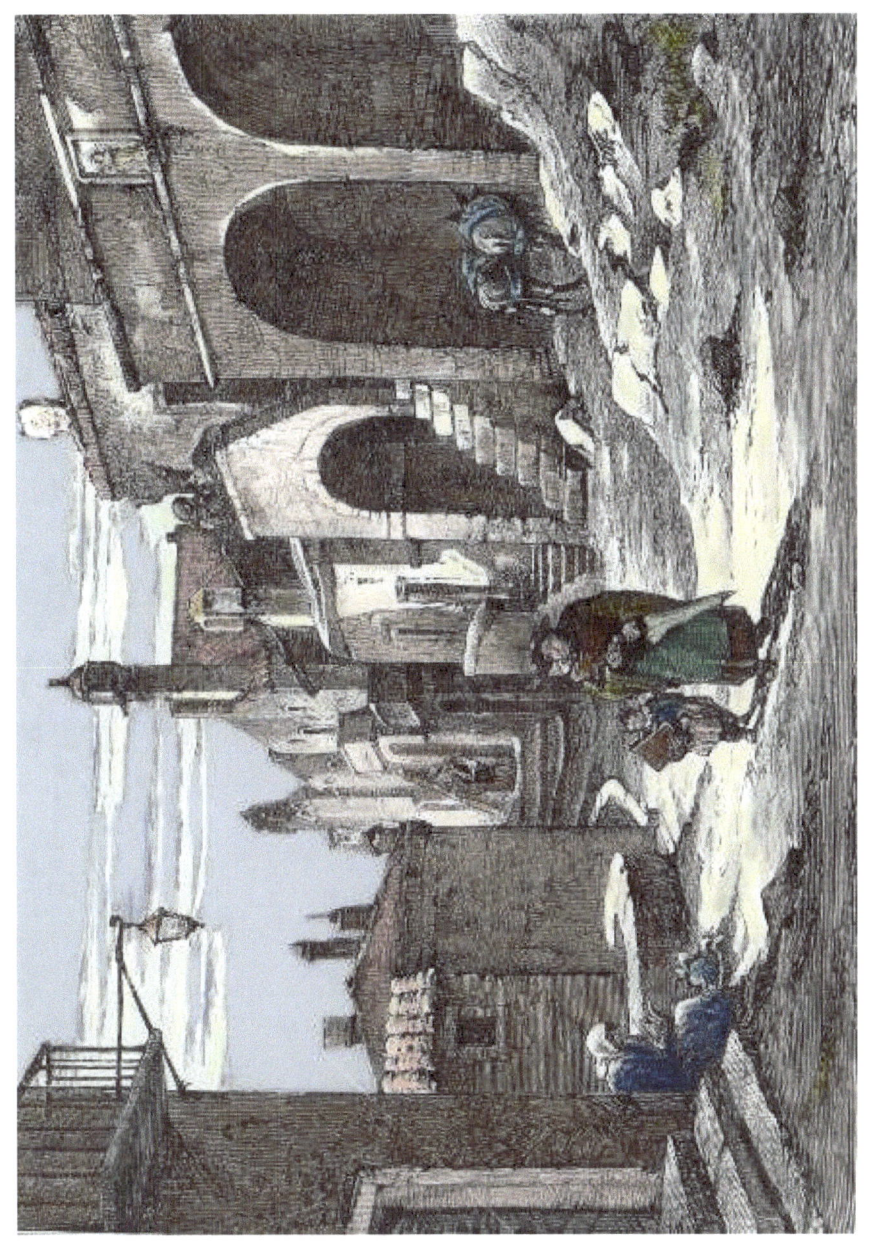

City of Monte Sant Angelo on Gargano Pennisula in the Apulia region

in the Province of Foggia in south central Italy

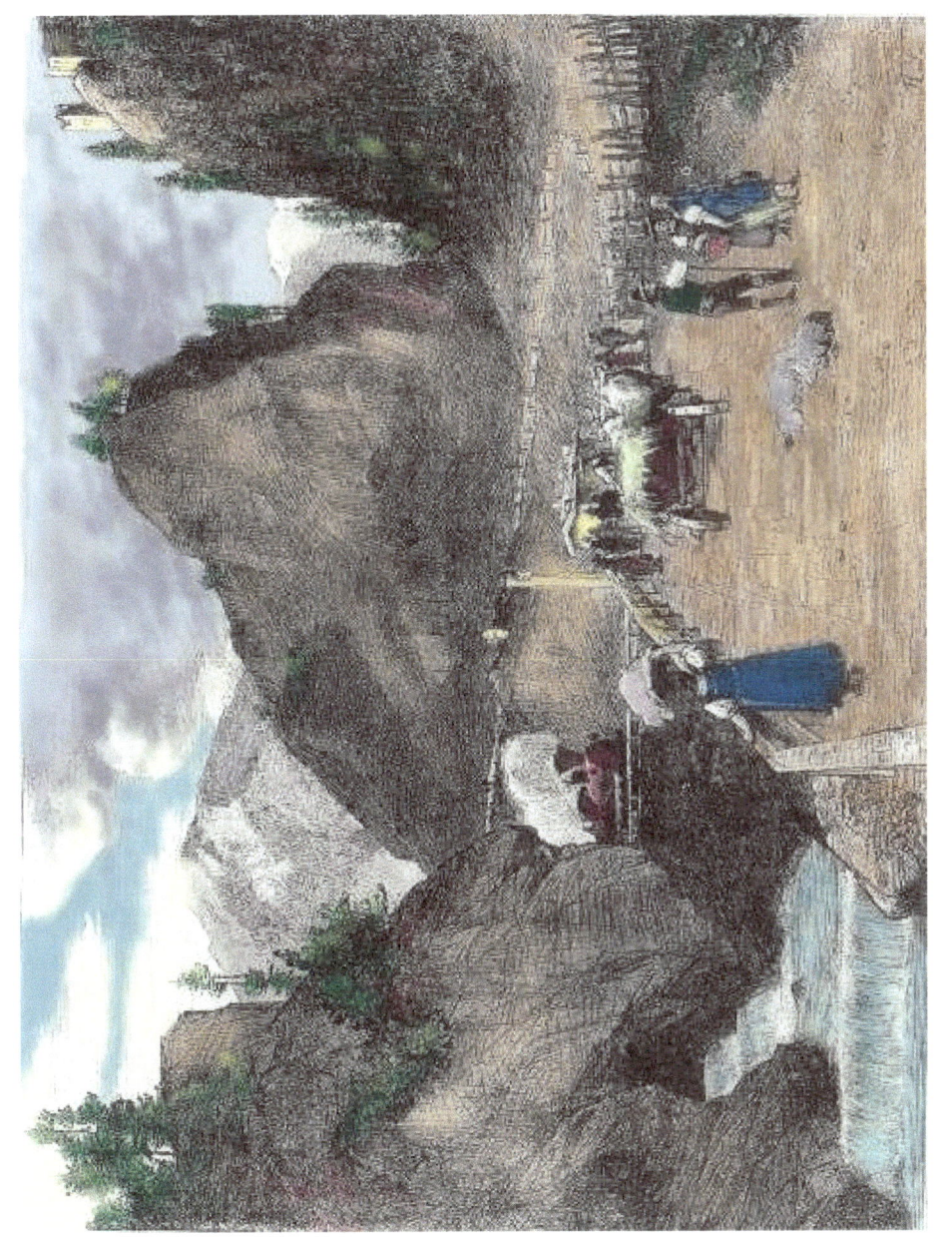

Brenner Pass – Mountain Pass through Alps between Italy and Austria in Province of South Tyrol

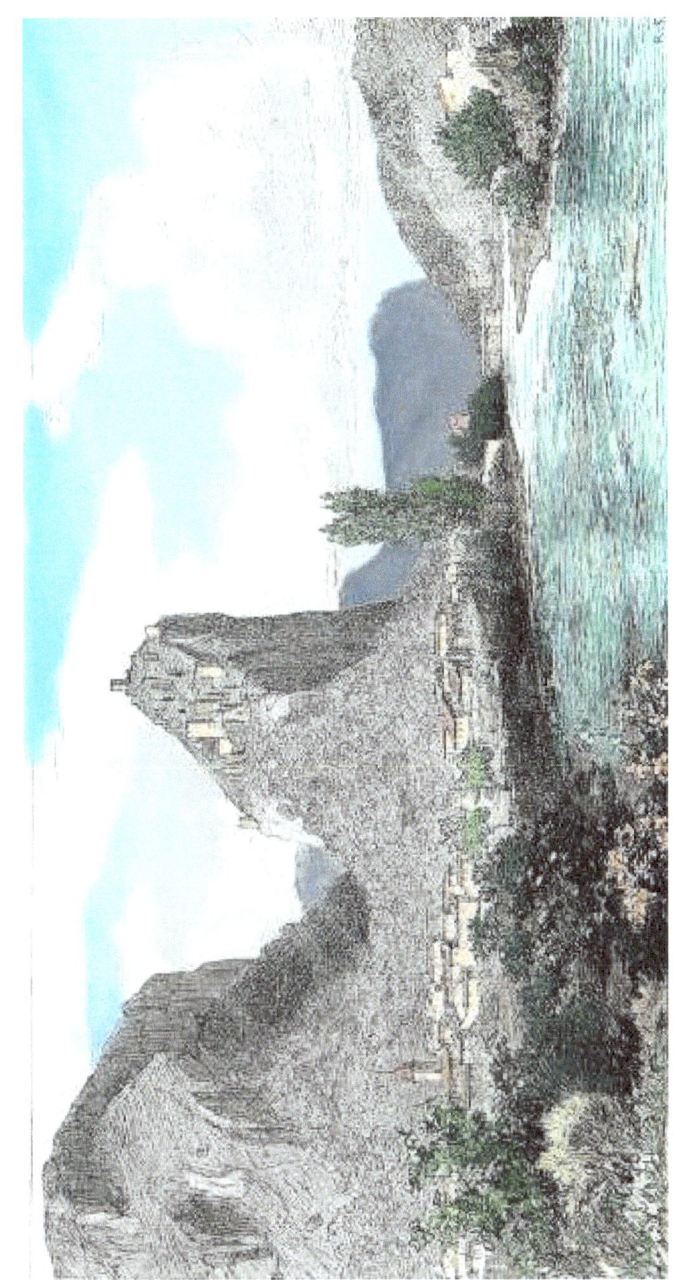

Arco Castle, resisdence of the Arco Counts in the middle ages, dominates the plain of the River Sarca town of Arco on north side of Lake Garda in Province of Trentino, NE Italy

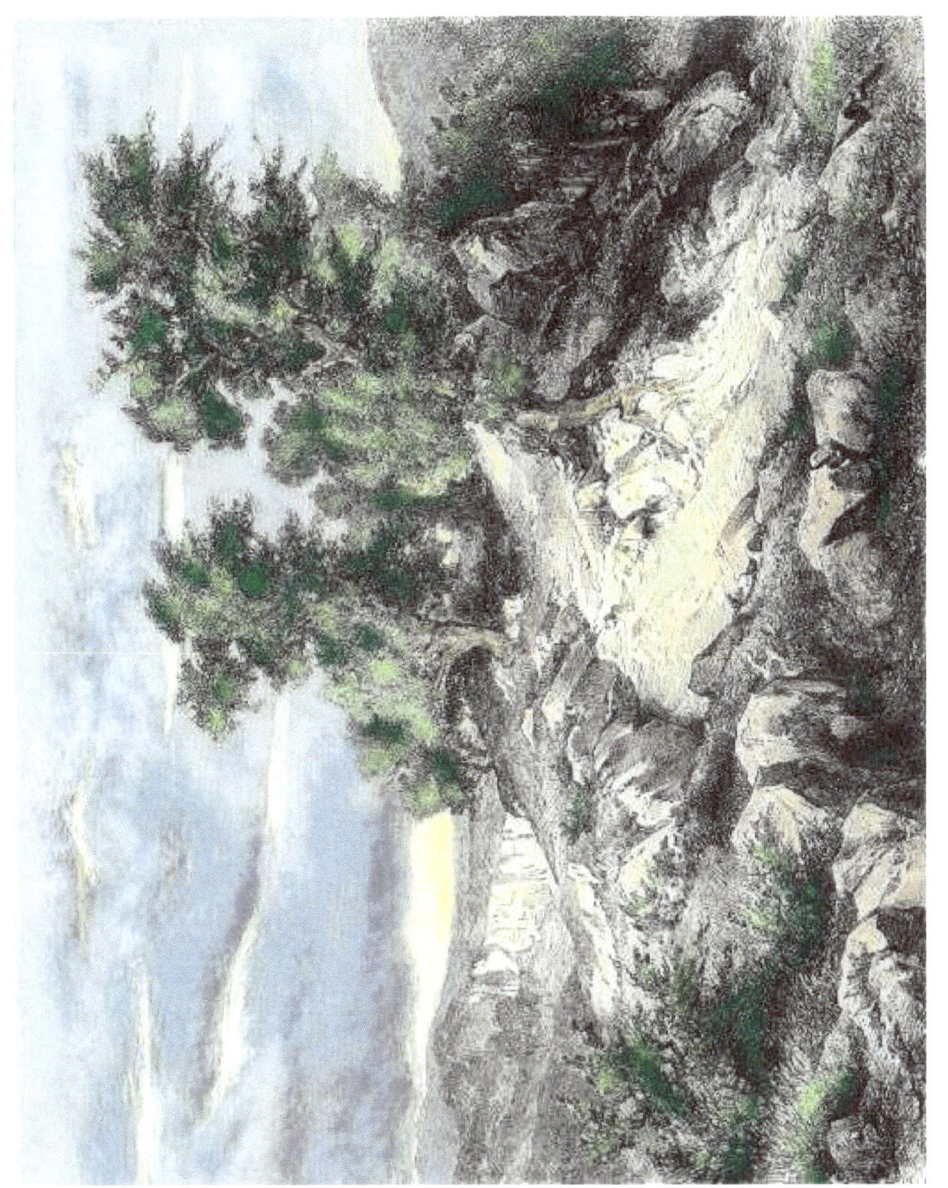

Tivoli – a town in the Lazio region, Province of Rome, in Central Italy

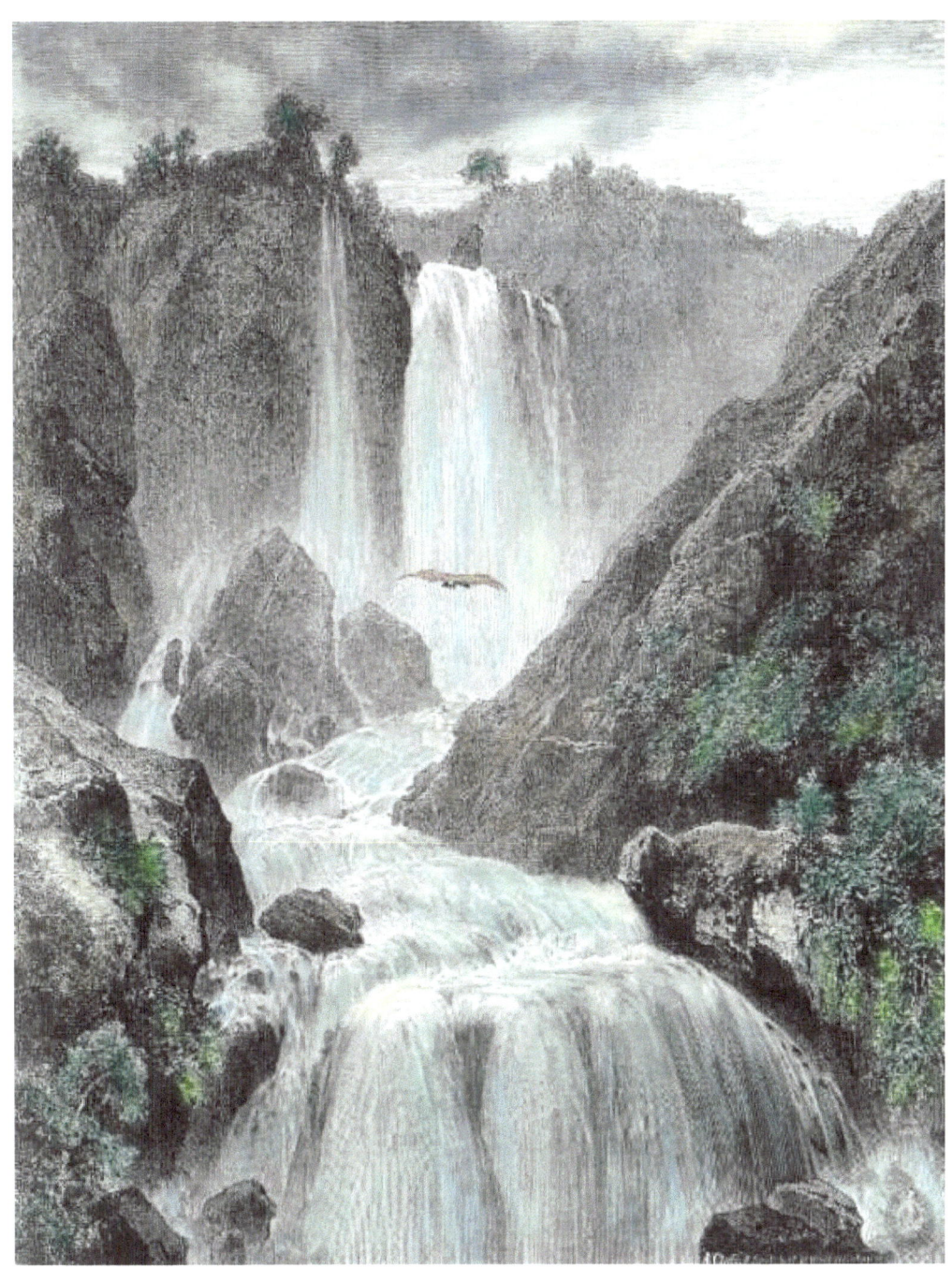

Waterfall of Terni , city in southern portion of region of
Umbria in Central Italy in Province of Terni

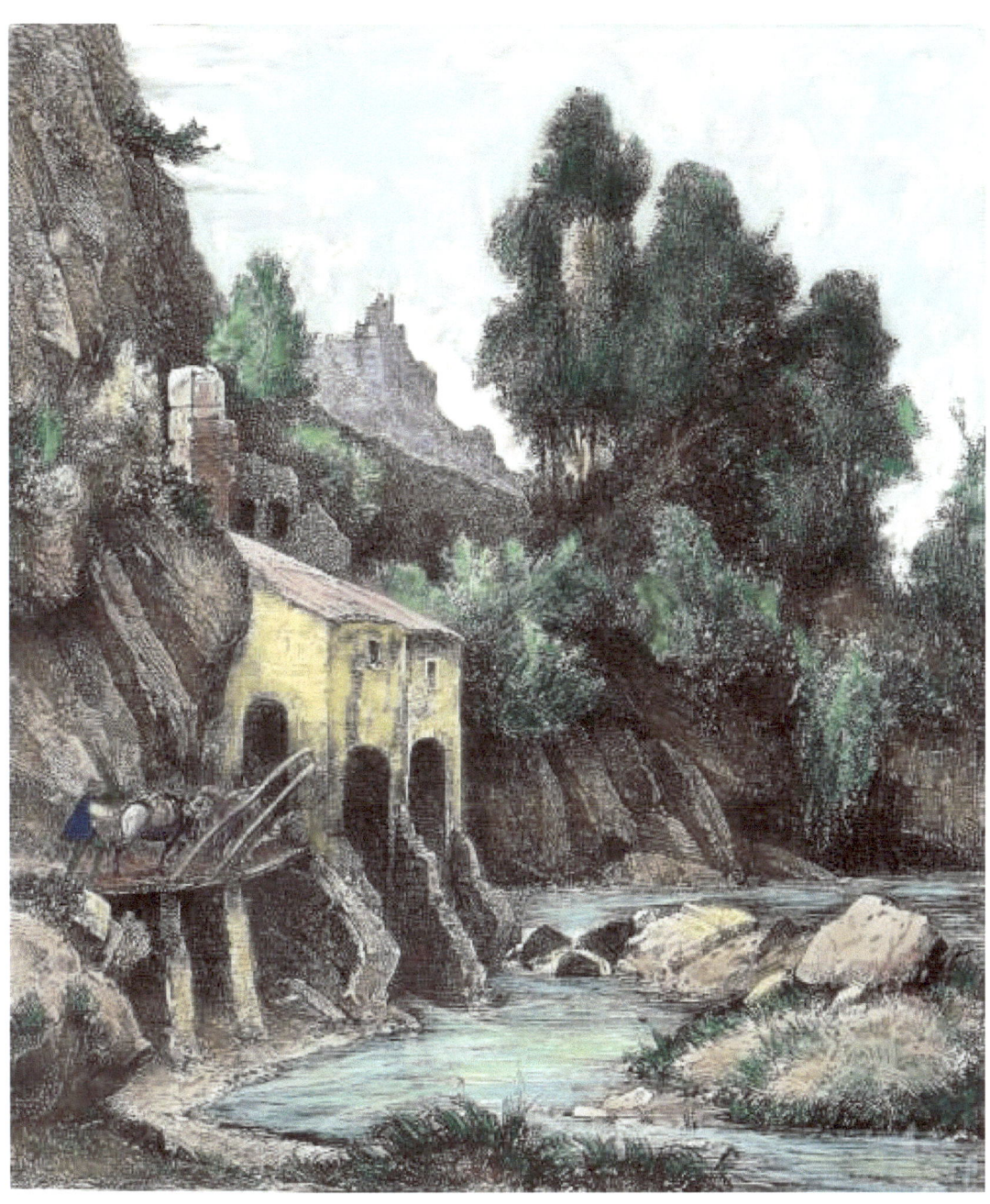

Mill in the town of Ariano Irpino in Province of Avellino In Campania region

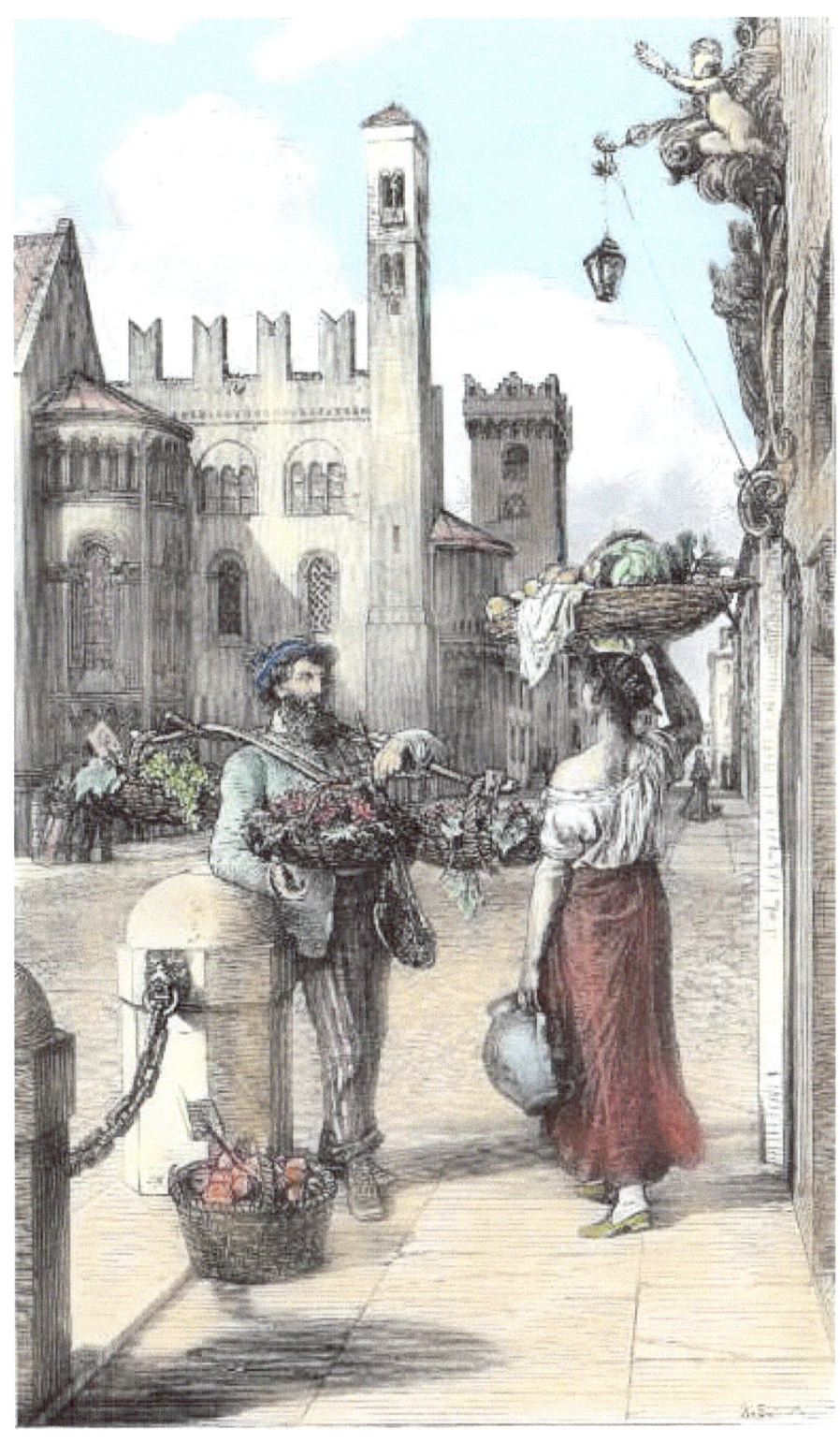

Merchants of Fruit in Province of Trentino (Trento)

In Northern Italy

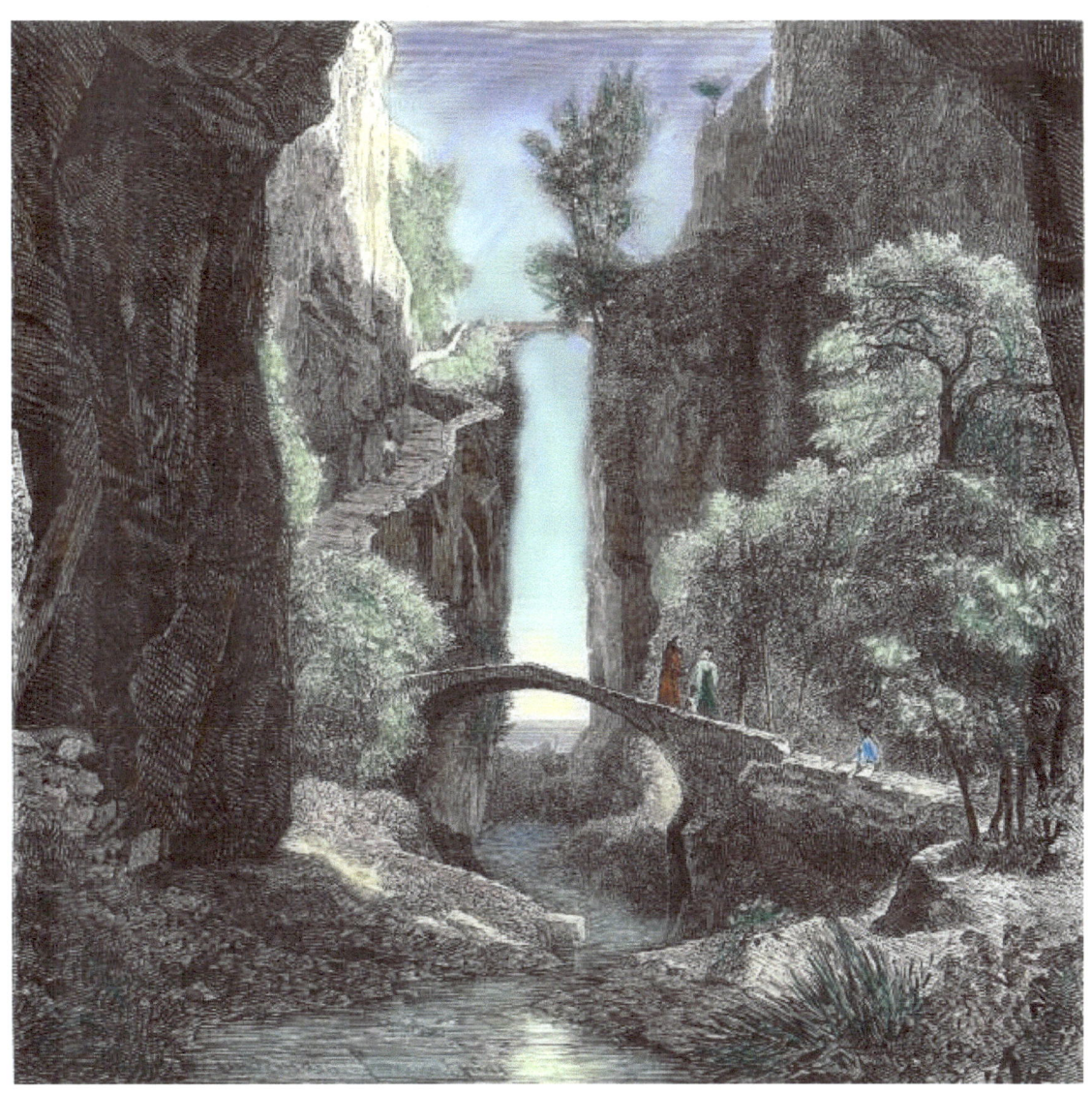

Gorge near Sorrento in Province of Naples

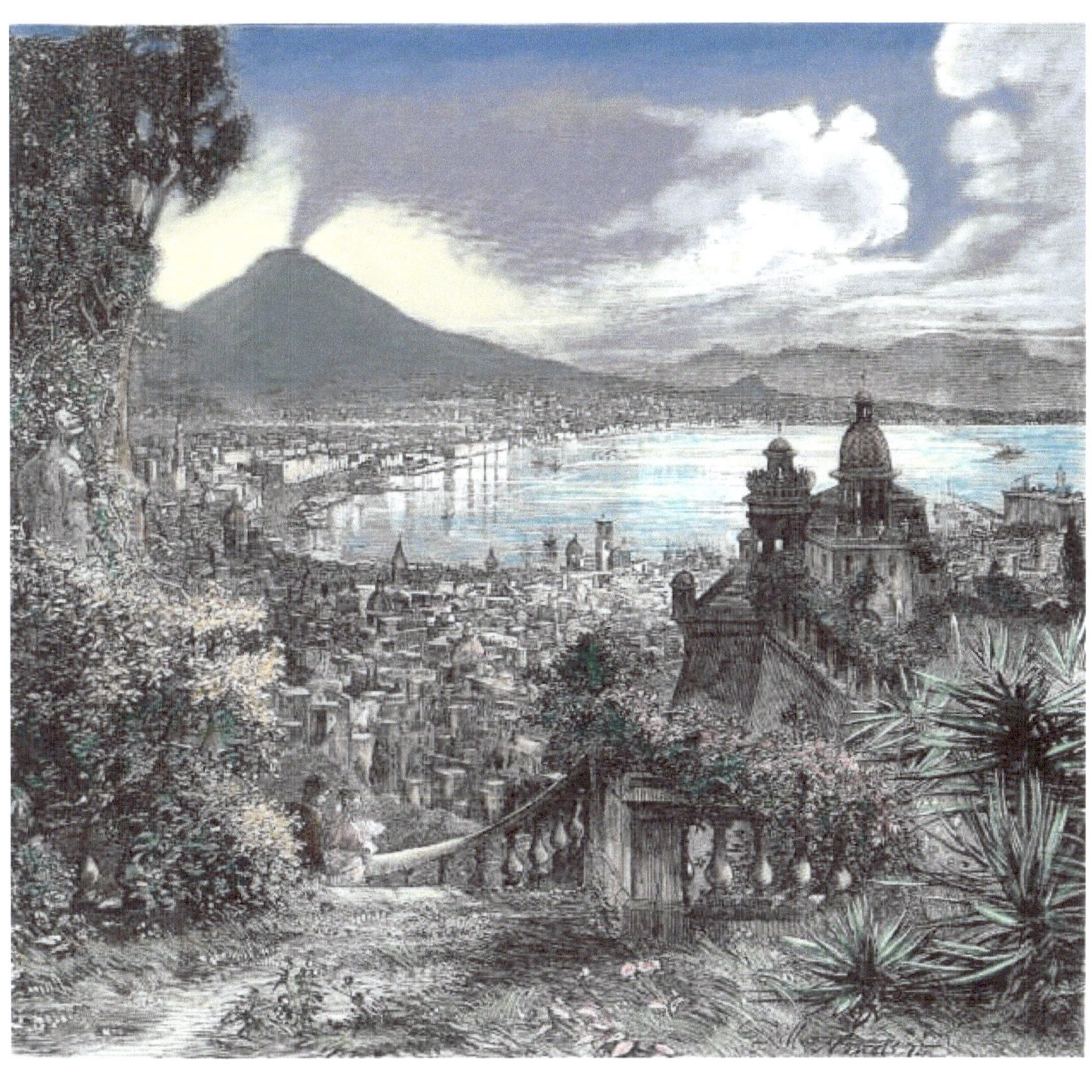

The Shores of Naples and Salerno

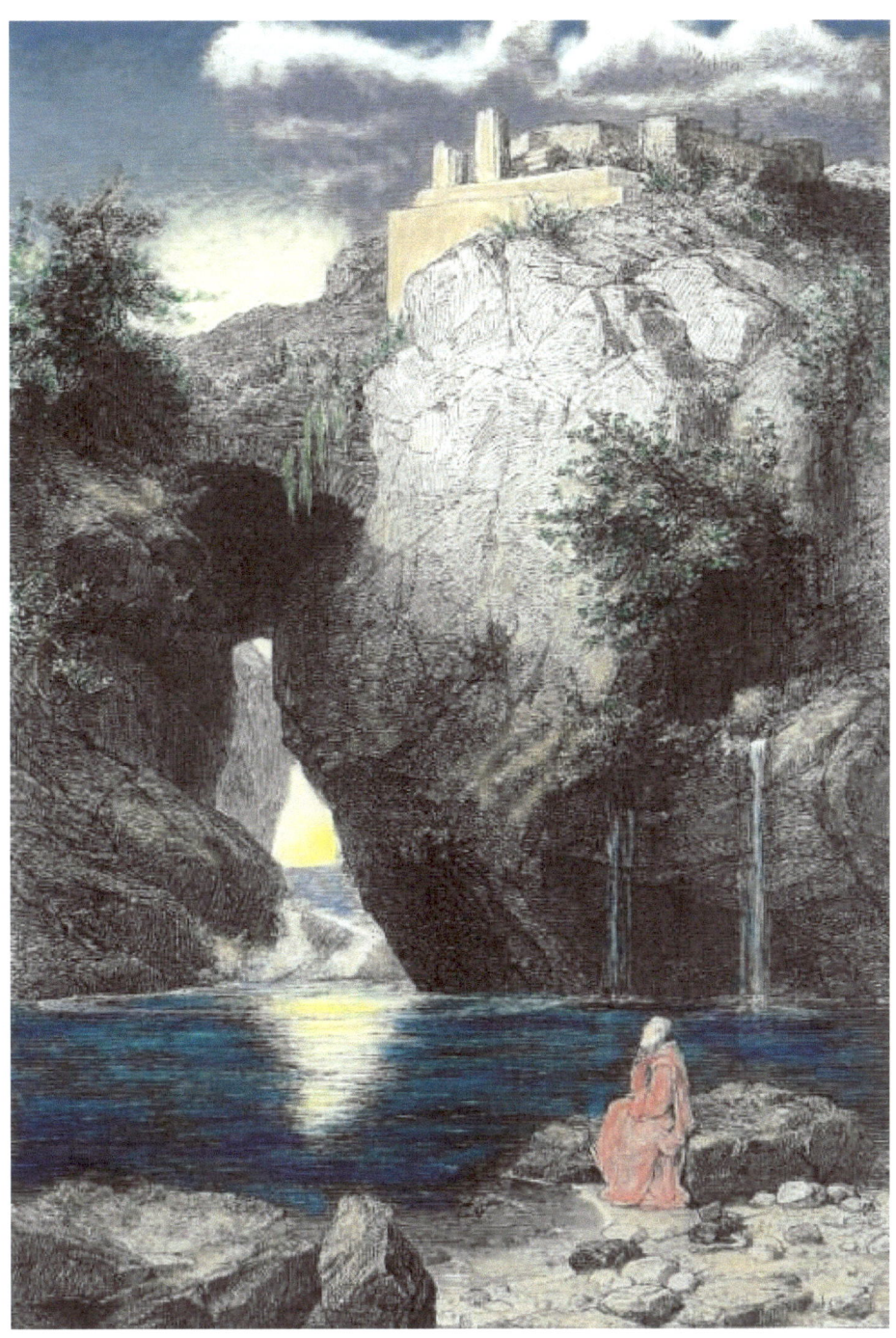

Bath of Diana

The Islands of Naples and Sorrento

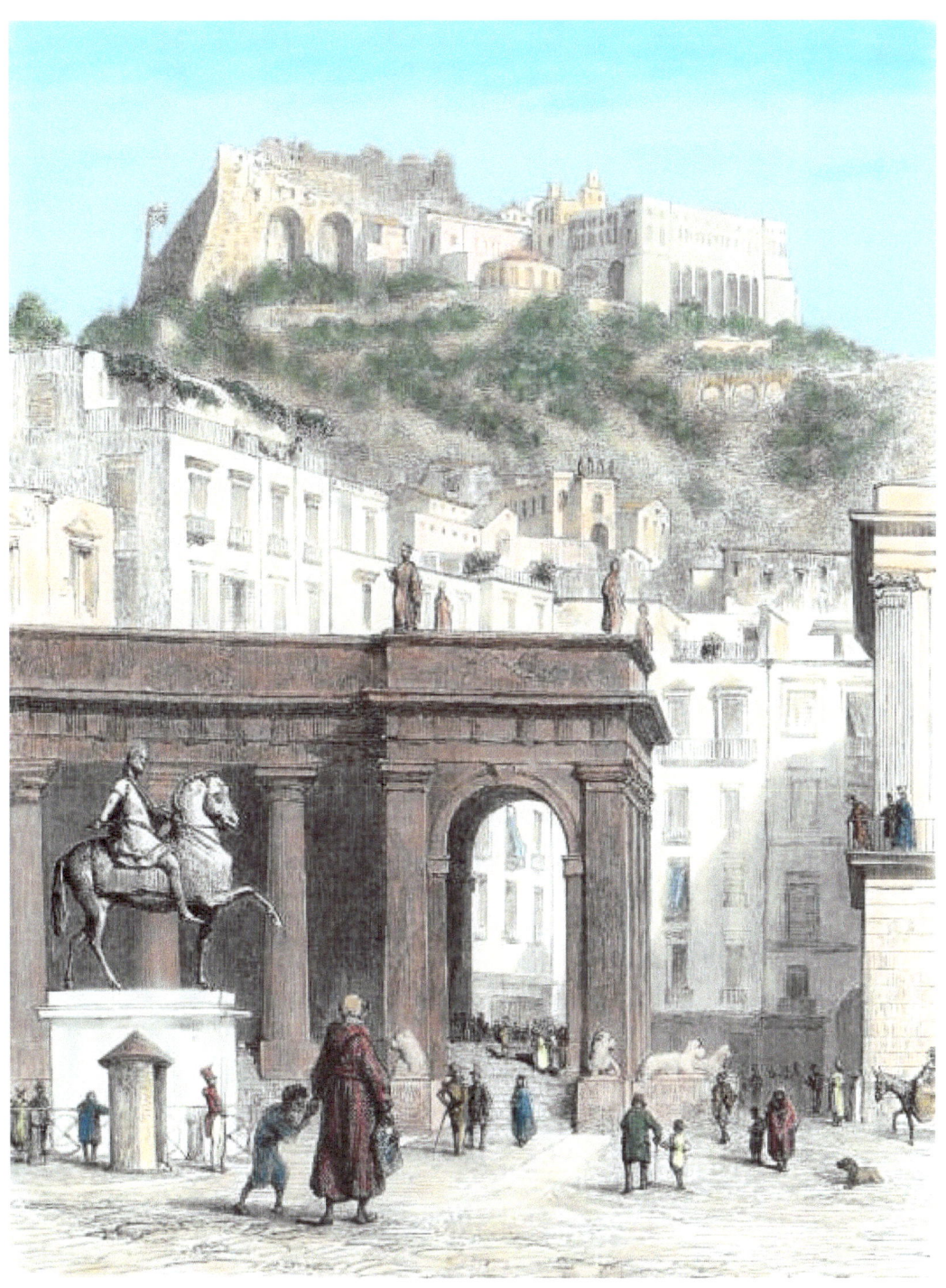

St. Elmo Castle

Perched on the "Vomero" dominates city of Naples

Statue of Ferdinand IV –King of Naples (1751-1825)

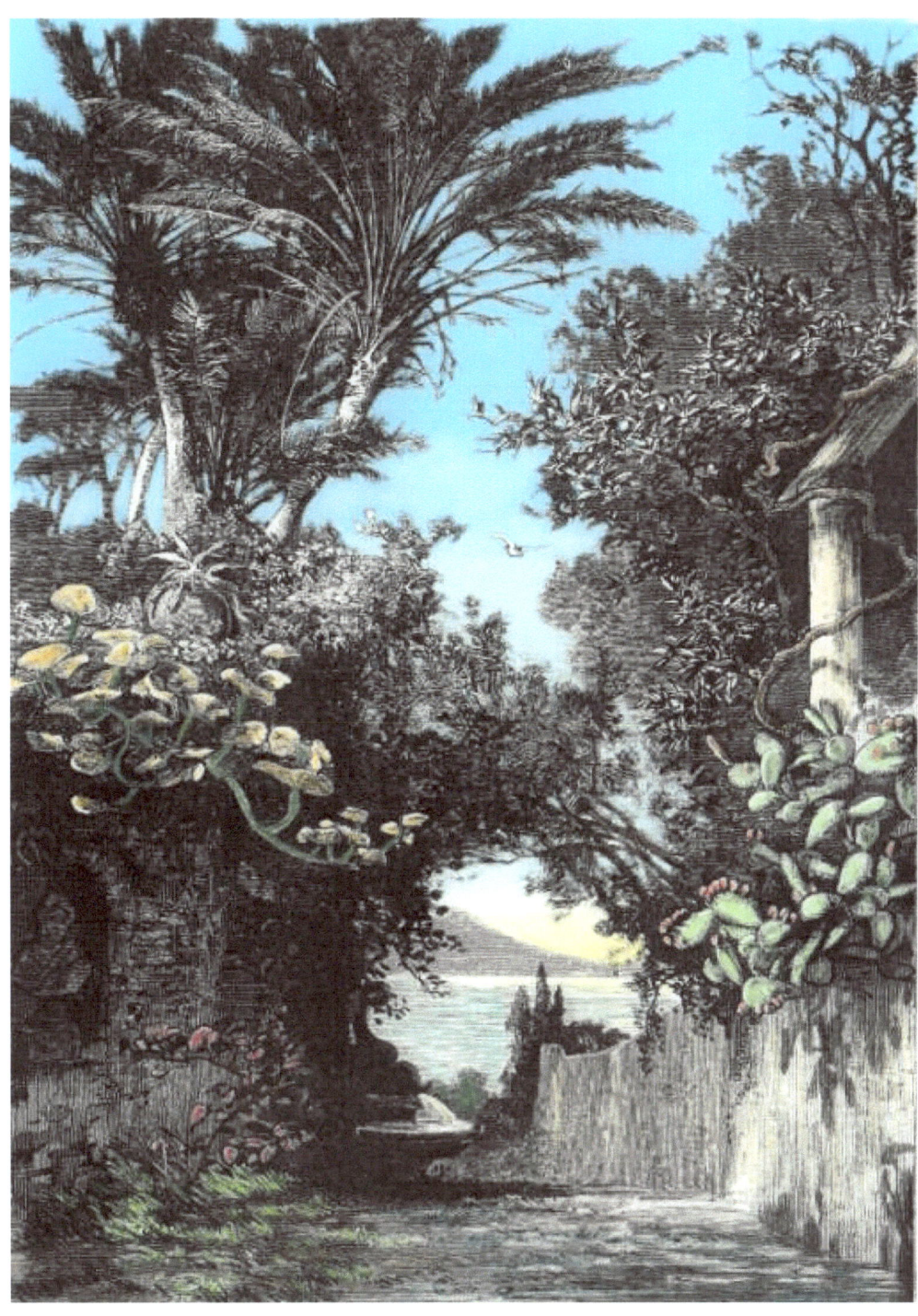

Naples

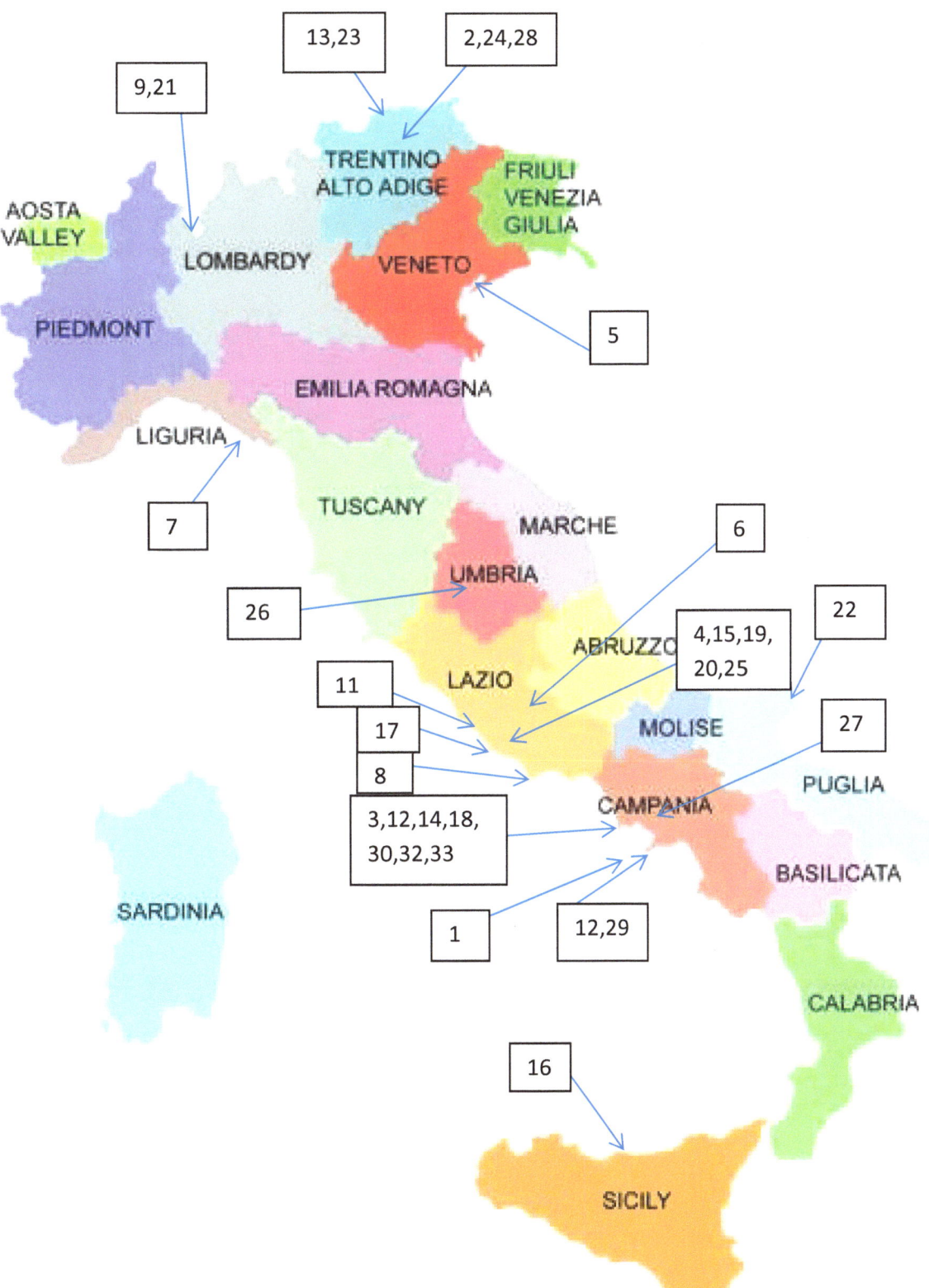

www.ingramcontent.com/pod-product-compliance
Lightning Source LLC
Chambersburg PA
CBHW050740180526
45159CB00003B/1297